W9-DFL-769

Leica
REFLEX PHOTOGRAPHY

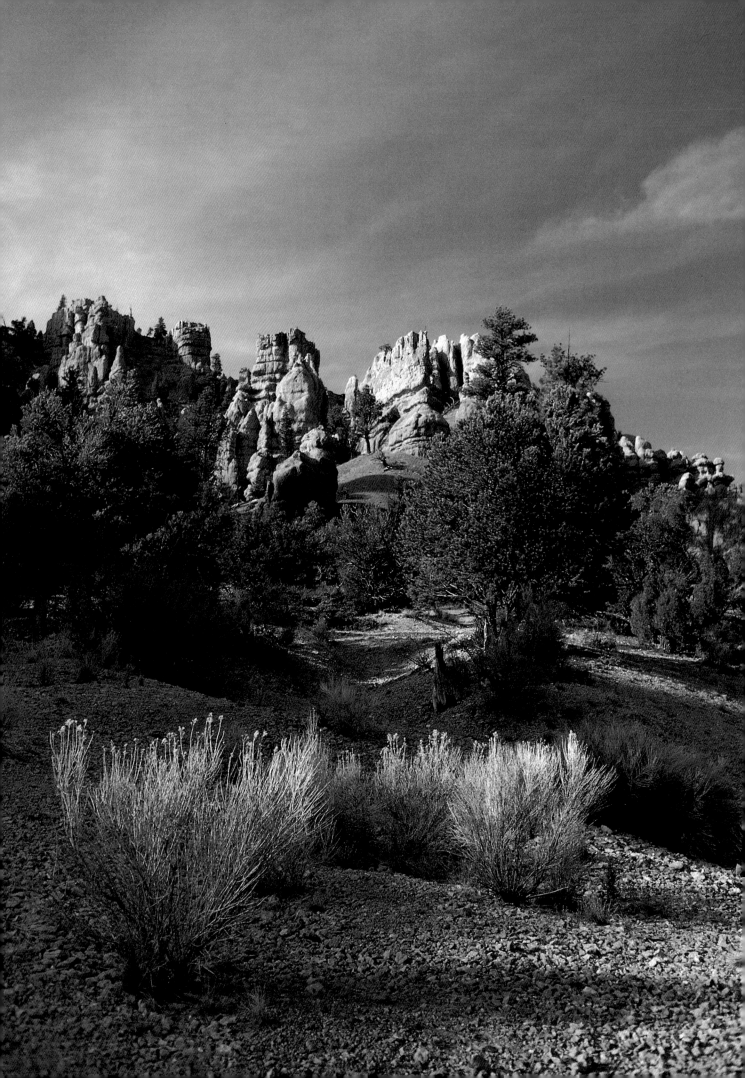

Leica
REFLEX PHOTOGRAPHY

BRIAN BOWER

DAVID & CHARLES
Newton Abbot London

PAGE 2: RED ROCK
CANYON, UTAH
Leica R5, 35/2
Summicron, 1/60 f5.6,
polariser
Kodachrome 25
Professional

SUPERIOR QUALITY
Leica R4, 100/4
Macro Elmar 1/8 f16
Kodachrome 64

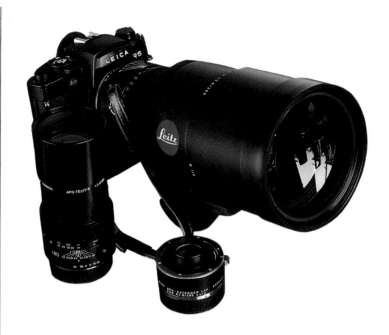

BRITISH LIBRARY CATALOGUING IN PUBLICATION DATA
Bower, Brian
Leica reflex photography
1. Cameras
I. Title
771.31
ISBN 0-7153-9903-9

Colour photography by the author

Typeset by Ace Filmsetting Ltd, Frome, Somerset
and printed in Singapore
by CS Graphics Pte Ltd
for David & Charles plc
Brunel House Newton Abbot Devon

CONTENTS

FOREWORD 7

1 LEICA REFLEX CAMERAS 8
A Brief History

2 CURRENT MODELS 14
The R5, the R6 and the R-E

3 LEICA 'R' LENSES 21

4 GETTING MAXIMUM SHARPNESS 39

5 USEFUL ACCESSORIES 47

6 EXPOSURE 57

7 CLOSE-UP PHOTOGRAPHY 64

8 PHOTOGRAPHING PEOPLE 78

9 LANDSCAPES 85

10 TRAVEL 96

11 NATURE AND WILDLIFE 109

12 FILM 117

13 ELECTRONIC FLASH 129

14 BUYING SECONDHAND 135

15 LEICA REFLEX COLLECTABLES 139

TABLES 143
Leica Reflex Cameras
Leica 'R' Lens Compatibility
Discontinued Lenses
Accessories for Older Lenses
'M' Visoflex Lenses on the Reflex Camera

ACKNOWLEDGEMENTS 148

BIBLIOGRAPHY 149

COLOUR ILLUSTRATIONS: *Technical Summary* 150

INDEX 152

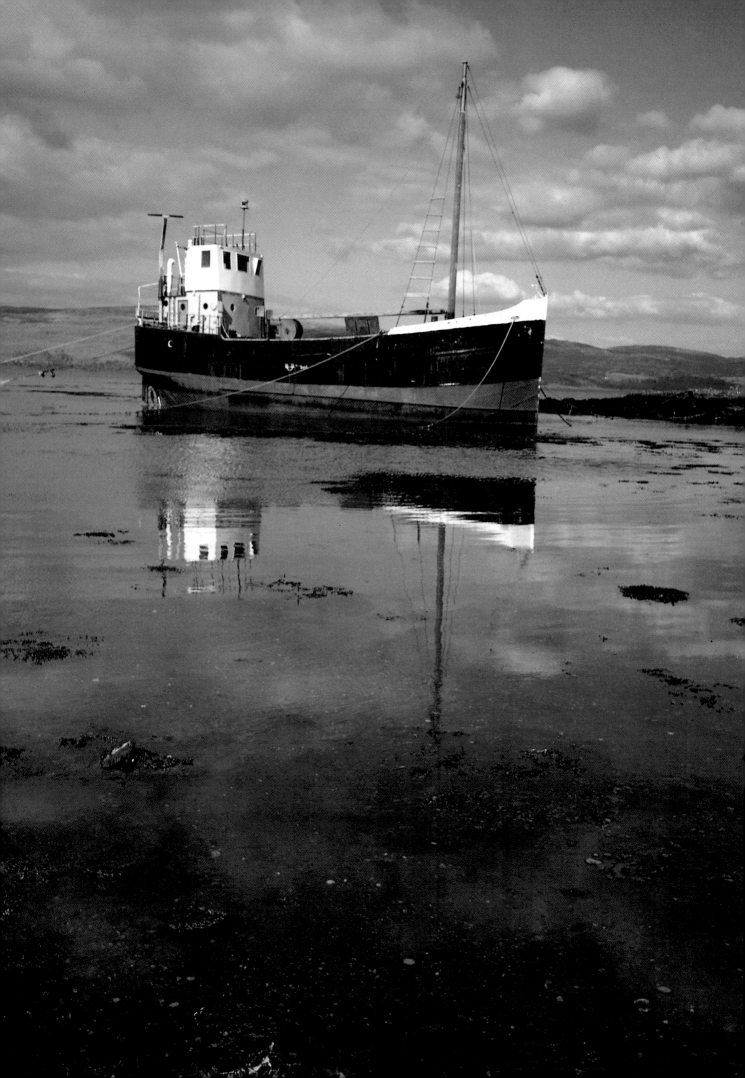

FOREWORD

My enthusiasm for Leica cameras stretches back over twenty years. An uncle lent me a Leica M2 and lenses while he borrowed my Japanese single-lens reflex (SLR). A month later, when the time came to return the M2, I was totally hooked on Leica precision and Leica optical quality.

Inevitably I soon had my own M2 and then an M4, and for a long period the rangefinder cameras suited my photography admirably. I have never parted with my 'M's and I still love to use them occasionally, but over the years the greater versatility of the Leica Reflex system has become of increasing importance to me. The convenience of reflex viewing for precise composition, for close-up and for long-lens photography, together with the option of a high degree of automation when required, is considerable. Add to this an extensive range of lenses of world-renowned quality, plus some well-chosen accessories, and you have a superior solution to almost any photographic problem.

With all this, there is a unique pleasure in handling instruments of such remarkably fine mechanical and optical precision. This positively encourages the photographer to go out and take pictures, matching the quality of the equipment with his very best technical and creative skills.

I do hope that this book will help you to make the most of your Leica Reflex camera system, and to enjoy photography with it as much as I do.

BRIAN BOWER

MULL, SCOTLAND
The tide was coming in quickly and I had to work fast to get my picture of the colours and textures in the water, along with the beached fishing boat and its reflection.

Leica R3 28/2.8
Elmarit 1/125 f5.6
Kodachrome 25

LEICA REFLEX CAMERAS

A Brief History

In spite of its outstanding position as the originator of precision 35mm cameras, Ernst Leitz GmbH, as it was then known, was late to develop a 35mm single lens reflex. That this should be so is surprising when you remember that the 'Ploot' add-on reflex housing for the company's early rangefinder cameras was introduced as far back as 1932, some four years ahead of the very first 35mm SLR, the Kine Exakta. Maybe the superiority of the M3 and M2 over the other top rangefinder cameras of the fifties and their consequent success gave Leica a wrong impression of the marketplace, but in 1965 when the Leicaflex 1 reached the public the company was seven years behind arch-rival Zeiss, which launched the Contarex at Photokina 1958. Perhaps much more significantly, it was six years behind the introduction of the ubiquitous Nikon F.

LEICA'S FIRST REFLEX

The first Leicaflex was a superbly built camera but was already out of date when it appeared. It lacked through-the-lens (TTL) metering, already available on a number of less expensive competitors, and the focussing screen, with its clear, see-through outer area and ability to focus only in the central microprism spot, was unsatisfactory to most people.

THE LEICAFLEX SL – INNOVATIVE AND TECHNICALLY SUPERIOR

Fortunately, Leica quickly realised this, and in 1968 the Leicaflex SL appeared. This not only thoroughly remedied the main criticism of the earlier models, but did so in such an elegant and efficient way that the Leica regained a technical and innovative edge.

The TTL metering via a semi-silvered area and mirror attached to the main reflex mirror gave a spot reading in a position exactly equal to the film plane. It was the most precise system available. The new focussing screen, consisting of coarse microprisms in the inner area and very fine ones over the remainder, was an optical *tour de force*. It provided excellent focussing accuracy with incredible brightness, and it was to be many years before other manufacturers achieved anything comparable. Even by the most modern standards the SL screens are first-class, their only drawback being that sometimes a very slight colour cast is caused by the coatings used. However, this only becomes noticeable when comparing them with a more neutral, modern screen.

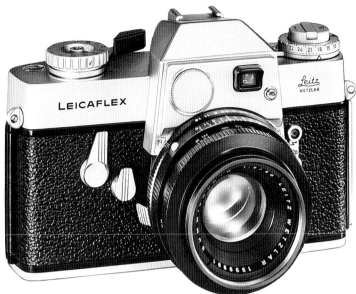

LEICAFLEX 1 1965
The first Leica Reflex.
Mechanically and
optically superb, with
1/2000 sec top shutter
speed but lacking TTL
metering

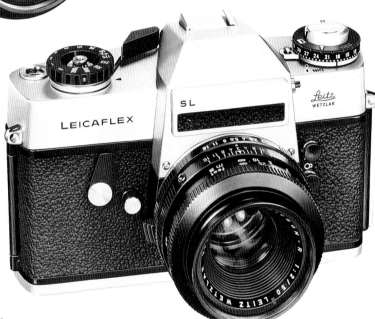

LEICAFLEX SL 1968
Trendsetting,
extremely accurate
TTL spot metering and
a stunningly bright all
microprism focussing
screen. Both features
put the camera well
ahead of its rivals

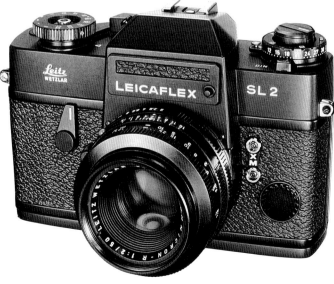

LEICAFLEX SL2 1974
This model included
many detail
improvements over the
SL, eight times greater
metering sensitivity,
hot shoe for flash,
display of stop as well
as shutter speed in the
finder and illumination
of the meter needle
when working in low
light

The system was steadily becoming more extensive, with lenses from 21 to 560mm and a motorised version of the camera also available. Close-up equipment was comprehensive, from a bellows unit and copying stand to the Elpro close-up lenses. As ever, in all cases the mechanical and optical quality provided by Leica was outstanding.

THE MAGNIFICENT SL2

There were, however, some gaps in the lens range, and when the SL2 came along in 1974 not only were there some very worthwhile detail improvements (eg eight times greater meter sensitivity, display of f stops as well as shutter speeds in the viewfinder, hot shoe etc) but the body was slightly reshaped and the mirror box redesigned to accommodate three new lenses (16mm fisheye, 24mm wide-angle and an 80–200mm zoom). These were based on Minolta optical designs but were re-engineered by Leica with quality control to Leica standards.

The SL2 was a magnificent camera, possibly the finest 'mechanical' SLR ever built, with a meter sensitivity that is still better than most current SLRs. Second-hand examples in good condition are highly sought-after and correspondingly expensive. The SL2 was only in production for a very short time, however, as once again Leica was fighting hard to keep pace with new developments.

On the technical front, reliable electronically controlled shutters combined with aperture-priority automatic exposure systems were already proving very successful, as evidenced by the Pentax ES launched in 1971. SLRs were becoming steadily more compact, the market leader in this respect being the Olympus OM1 of 1972. Competitors' production costs were cut sharply as camera manufacturing techniques were revolutionised with increasing use of plastics, microchips and ever more automated production lines. Canon set the pace with its AE1, and selling prices came down dramatically.

R3 – FURTHER COLLABORATION WITH MINOLTA

In volume terms, Leica was (and still is) tiny compared with the major Japanese manufacturers. It could not support alone the research and development or the tooling costs of a completely new electronic camera. Already it was collaborating with the Minolta company in a number of areas (including the lenses mentioned above and the Leica CL compact rangefinder system). Naturally enough the next Leica SLR, the R3 of 1976, drew heavily on this connection.

The highly regarded manual/aperture-priority auto Minolta XE1, introduced in 1975, already incorporated a shutter jointly developed by Leica and Copal – the CLS. Leica engineers now took the basic XE bodyshell, strengthened it in a number of places, built in their own mirror box and finder optics, added a spot metering mode similar to that of the SL2 to the XE1's averaging system along with one or two other special features, and the R3 was born.

The R3 was an excellent camera combining the best of Japanese technology with Leica innovation, engineering skills and quality control standards. The spot metering mode, with a

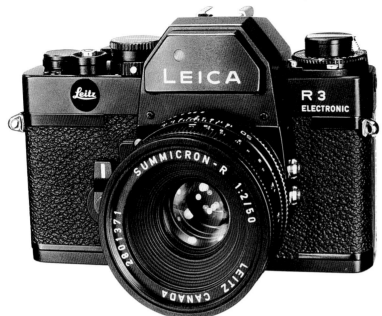

LEICA R3 1976
Leica's first automatic
camera. Aperture-
priority auto and
manual each with spot
or averaging metering.
Equipped with
electronically
controlled Leica/Copal
shutter

LEICA R4 1980
Compact multimode
(aperture priority,
shutter priority,
programme, manual,
spot and averaging
metering, electronic
(Seiko) shutter). Takes
motor winder or motor
drive and accepts
interchangeable
focussing screens

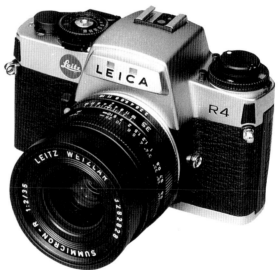

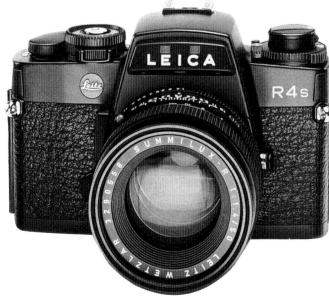

LEICA R4s 1983
Identical with the R4
except that camera
does not have
programme or shutter
priority modes.
Improved R4s Mod 2
(P in USA) introduced
in 1986

simple, convenient method of locking the reading by a second pressure on the shutter release, was classic and many experienced photographers realised just how effective and controllable auto exposure could be.

The first few R3s were assembled at Wetzlar but very quickly production was transferred to a new Leica plant in Portugal, which enabled significant cost reductions to be achieved. This was essential as the relative cost of other SLRs – even the high-quality 'professional' machines such as the Nikon F2 and Canon F1 – had dropped considerably. Although Leica cameras never have sold on price it was essential not to get too out of touch with accepted price levels.

One of the difficulties that Leica had to face up to with the R3 was a change in the lens mount – or more precisely the meter coupling cams incorporated into it. In 1968, when the SL succeeded the original Leicaflex, a second cam had been introduced, and with the R3 a very simple but still essential third cam had to be provided to index the lens maximum aperture. The subtleties of single, twin and triple camming are complex (see table, p144) but it is true to say that Leica, with only one or two very rare exceptions, has made it possible to use even the very earliest 'R' lenses on its latest camera and vice versa.

MULTIMODE COMPACT R4

Good though it was the R3 was in fact a stop-gap, intended to keep Leica in the market whilst it was developing a much more advanced camera. This emerged in 1980 as the R4, a new compact body retaining the manual and aperture-priority spot or averaging auto exposure modes of the R3 but with the addition of programme and shutter speed-priority modes. Interchangeable focussing screens were also featured and the camera was designed from the start to accept a motor drive or winder. The body is comfortable to hold, handles well and feels right, and it appealed immediately to those who thought that earlier Leica Reflex cameras compared unfavourably with the 'M' in these respects. Technically the R4 again put Leica right at the head of the field.

The R4 was in production for seven years. As would be expected, over such a period a number of internal improvements were made, resulting in a very well-proved camera.

Along with the R4 we should mention the R4s, introduced as a budget model in 1983. This is identical to the R4 except that the programme and shutter speed-priority modes are omitted. All other features are retained and many photographers found that the simpler model met their requirements more than adequately, with a worthwhile cost saving. In 1986 the R4s Model 2 (USA Model P) was introduced, with some minor detail changes.

All Leica SLRs, other than the very first Leicaflex, have incorporated a spot metering facility. It is interesting that after the introduction of the R4, other manufacturers began to recognise its merits for a competent user and to incorporate it into their flagship models.

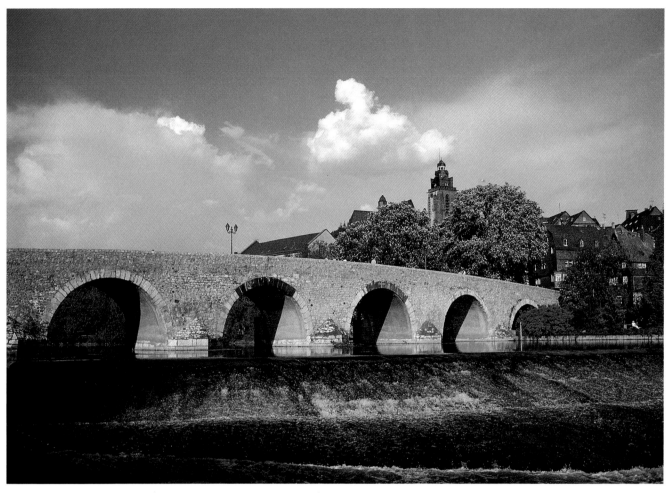

THE OLD BRIDGE AT
WETZLAR
A well-known view to
all Leica enthusiasts
who have visited the
Leica works or the
Leica Akademie at
their Mecca.

Leica R4, 21/4
Super Angulon 1/125 f5.6
Kodachrome 25
Professional

AUTUMN IN
MANHATTAN
The efficient exposure
system of the
automatic Leica
cameras still allows the
photographer good
control in difficult
against-the-light
situations such as this.

Leica R4, 21/4
Super Angulon 1/60 f8
Kodachrome 25

CURRENT MODELS

The R5, the R6 and the R-E

These cameras are all further developments of the R4. They use the same basic bodyshell, thus ensuring that many R4 accessories such as viewing screens, motor drive and winder are interchangeable, but they represent quite different directions of development. The R5 takes the automatic facilities of the R4 a stage further, with a variable programme mode and automatic TTL flash metering. On the other hand the R6, although incorporating the automatic flash metering, in every other respect reverts to fully manual operation with a mechanical rather than electronic shutter. The R-E is essentially a simplified version of the R5, without the shutter-priority or programme modes.

R5 – MORE AUTOMATION AND MANY DETAIL IMPROVEMENTS

After six years in production there was a need to update the R4. In addition to the major changes of variable programme mode and TTL flash metering, Leica incorporated many detail improvements which experience in the field had suggested would be welcomed by photographers.

IMPROVED VIEWFINDER

The most obvious gain is the increased viewfinder brightness. The new type of focussing screens (which can be fitted to the R4 too) are claimed to be one stop brighter than (ie twice as bright as) the old ones. If anything, this claim seems understated. The plain screen in particular is a vast improvement and I now use the grid version as a standard screen. Not only are the screens brighter but the quality of the image, particularly away from the centre, is much improved. Further, for the first time on a Leica since the IIIg of 1957, dioptre correction of the finder eyepiece has been incorporated.

Failure to correct for eyesight defects which prevent proper vision of the focussing screen is a major cause of inaccurate focussing and consequent loss of quality. The -2 to $+2$ correction built in will be a valuable aid to many. This is not a great advantage for sufferers from astigmatism, but what does help them considerably is the additional eyepiece relief that now permits viewing the whole screen when wearing spectacles. However, this has only been achieved with some reduction in viewfinder magnification.

There are changes in the presentation of information in the viewfinder – much neater generally, but of particular value is the

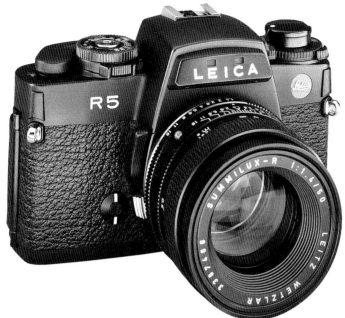

LEICA R5 1987
Based on the R4
bodyshell but with
many improvements.
Shutter top speed is
now 1/2000 and the
camera features TTL
flash metering, dioptre
correction of
viewfinder eyepiece,
variable programme
mode and improved
exposure compensation

LEICA R6 1988
Manual-only version of
R5 with mechanical
shutter. Meter two
stops more sensitive
than R5, mirror lockup
to avoid camera
vibration at slow
speeds and illuminated
finder information.
Retains TTL flash
system of R5

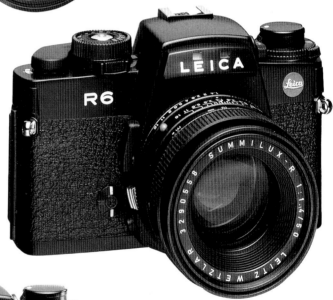

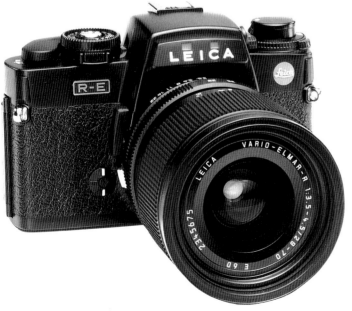

LEICA R-E 1990
R5 without shutter
priority and
programme modes

elimination of the incursion of the shutter speed/f stop diodes panel into the image area. This certainly helps precise composition. Another useful practical improvement is that the viewfinder display stays illuminated for about 10sec after touching the shutter release. On the R4 removing the first slight pressure switches off the display immediately.

Still on the display, one further idiosyncrasy of the R4 is that when you use the very convenient memory lock (a slight extra pressure on the shutter release) to hold a spot reading, the actual read-out in the finder continues to fluctuate. This can be confusing at times and the R5 now displays the locked reading.

Every single one of the above improvements is worthwhile but the much brighter finder and the ability to see the whole of it when wearing spectacles are the features of greatest value in practical picture-taking. I particularly appreciate the remarkably bright plain screen for long lens and close-up work.

HIGHER SHUTTER SPEED

Leica's first SLR, the Leicaflex 1 of 1965, introduced a 1/2000sec top shutter speed in advance of any other major camera manufacturer. This was retained on the later SL and SL2. All the more surprising was that the R3 and even the later R4 only offered 1/1000sec when 1/2000 had become common and 1/4000 was not unusual.

Whilst I believe that the real value of the 1/4000sec shutters lies in their higher X synch speed of 1/250sec, I have on many occasions been frustrated by the lack of any 'headroom' above 1/1000sec on the R4. Because the mode gives spot metering I prefer to use my R4 in aperture priority. With long lenses and/or action subjects normal practice is to select a stop that gives a shutter speed of between 1/500 and 1/1000sec. Unfortunately a slight increase in lighting levels can take the shutter speed over 1/1000sec and exposure is then unreliable.

For this reason a reliable 1/2000sec top speed was long overdue on an automatic Leica 'R', so it is very pleasing to be able to have this on the R5. If there is a disappointment it is that the maximum flash synch speed is still 1/100sec – too slow really for convenient work with fill-in flash, especially when we now have TTL flash metering which makes all types of flash photography – including fill-in techniques – so much easier and more flexible.

TTL FLASH

The R5 is used with SCA 300 system flashguns. The SCA 351 adapter gives a full TTL metering facility and there are excellent units available from Bauer, Metz and others.

There is no doubt that TTL eases a lot of the difficulties when using flash. You don't have to remember to set a particular film speed on the gun and then set a particular stop on the camera. Any compensation needed at higher image ratios in close-up photography is automatically taken care of, and in the case of fill-in flash the operation and calculation can be simplified. You have a full range of stops to work with, which can be especially valuable with bounce flash, and of course the display in the finder tells you when the gun is fully charged and whether sufficient power was available to ensure a correct exposure.

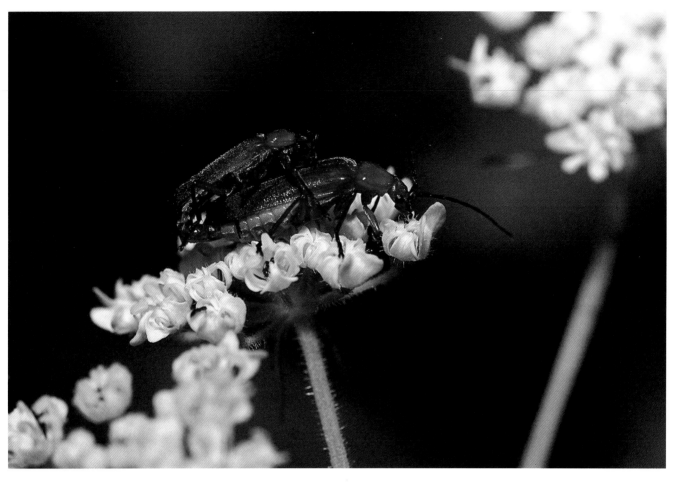

VARIABLE PROGRAMME MODE

I have great confidence in the performance of my Leica lenses at wider apertures and am a firm believer in higher shutter speeds to avoid any possibility of camera shake. The programme mode on the R4 often sets shutter speeds too low for comfort and I have never bothered to use it since some initial experimentation.

A major innovation of the R5 is that in effect it allows you to create your own programme. You can set the minimum shutter speed below which you do not wish to go until the lens has opened to its maximum aperture. Only from that point does the camera set slower shutter speeds as the light worsens. Thus, with a 180 f3.4 lens, if the shutter is set at 1/500sec the programme will give 1/2000 at f6.8, 1/1000 at f4.8, and 1/500 at f3.4, and only then will it start slowing the shutter. This is especially useful when working in a hurry.

It is interesting to note that the shutter-priority mode on the R4 (and the R5) is in fact part programmed. With an automatic SLR it is technically easier to control the shutter speed precisely (because it is electronic) than the aperture, which is a mechanical operation. Some of the more professionally-oriented SLRs, like the R4 and R5 when in shutter-priority mode, quickly recheck the exposure after the diaphragm has stopped down and then trim the set shutter speed. This allows for any slight undershoot or overshoot of the aperture blades and gives much more precise exposure.

INSECTS MATING
A valuable feature of the R5, R6 and R-E cameras is automatic TTL flash metering with suitable flashguns. This is particularly convenient for close-up photography.

Leica R6, 100/2.8 Apo Macro with Elpro, 1/60 f16 Fuji Velvia

A consequential effect is that if, because of insufficient light, the lens cannot open up enough to match the preset shutter speed, the camera will set a slower speed. The trouble is that although you will get correct exposure, the only indication that the shutter speed has been modified is a warning light. Instead of the 1/500 you thought you were getting, you might only have 1/60. This also happens with the variable programme mode but at least with this you get a read-out of the shutter speed being set and know what to expect. It would be nice to have the stop being set displayed too, but in practice when you are in hot pursuit of a picture you tend to ignore everything but focussing and framing, whilst for more studied situations the likelihood is that manual or an aperture-priority mode would be favoured.

MODE SWITCHING AND EXPOSURE COMPENSATION

Two other worthwhile improvements were first introduced and proved on the R4s Model 2. First, the mode selector lever has much more positive locking to avoid inadvertent switching to a different mode. This can and does happen on the R4 if you are not alert.

Second, the exposure compensation setting is vastly improved. In normal photography I will not use compensation. I prefer to use spot metering plus AE lock to read a darker or lighter tone if I wish to bracket or modify exposures. In spite of the warning signal in the finder, it is too easy to forget to zero the compensation. Some years ago, with the R4, I finally vowed I would never use compensation again after inadvertently exposing half a roll of Kodachrome at plus one stop. Using the compensation of the R4 is a fiddly business anyway, so on the occasions when I cannot read another tone and have to adjust exposure (eg sometimes when copying or working on a tripod), I switch to manual.

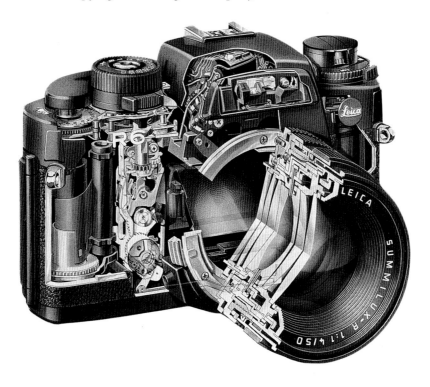

LEICA R6 CUTAWAY

Now, with the R5, compensation is delightfully simple and convenient to use. It is particularly valuable when working off a tripod or copy stand – but for handheld work I still prefer to use spot metering variations.

R6 – CONCENTRATION ON BASICS

Many professional photographers have demanded a reflex version of the redoubtable rangefinder M6. The R6 is the answer. This model uses the same bodyshell and has many of the features of its brother R5, but there is one critically important difference. The shutter is mechanically and not electronically controlled and thus is not at all dependent on battery power.

Electronics are retained for both normal and flash exposure metering through the lens, but if need be the camera can of course be operated without these aids – an important matter for those photographers who may be operating in arduous conditions in the middle of Africa or a distant war-torn country.

Except for flash, which is the same as the R5, there are no automatic exposure modes and all settings are manual. The spot and averaging measuring options are both retained for use with the manual setting, however. The metering system is four times as sensitive as the R5. There is still an exposure compensation feature but this is of practical use only with the automatic TTL flash metering, as any other compensation can be applied manually.

Two very interesting new features are introduced, a mirror lockup and viewfinder illumination. The mirror lockup last seen on the original Leicaflex is particularly valuable when making

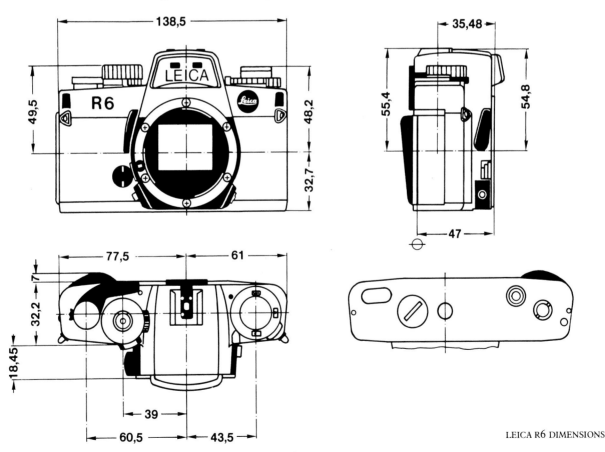

LEICA R6 DIMENSIONS

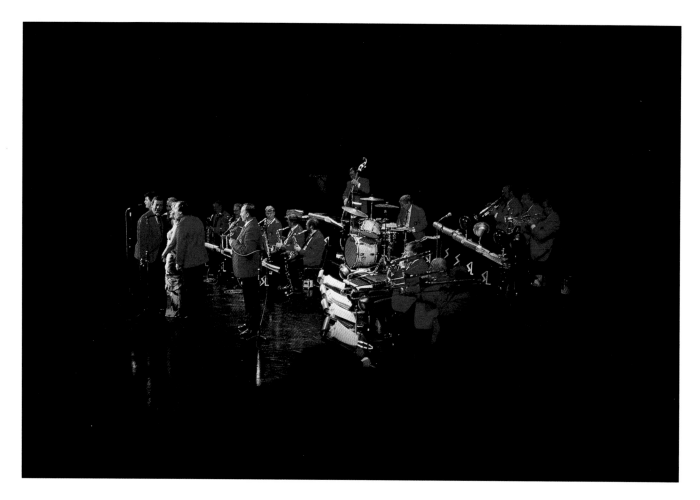

THE SYD LAWRENCE
ORCHESTRA
The R6 features a
small diode that can be
switched on to
illuminate the f stop
and shutter speed
settings. This is
especially helpful when
working in darkened
situations such as a
theatre.

Leica R6, 90/2
Summicron 1/125 f2
Kodachrome 200
Professional

exposures in the range ½ to 1/30sec. Even when using a tripod there is always some slight residual vibration from the mirror release and automatic diaphragm, and for some close-up subjects this can be critical. Using the independent mirror release locks up the mirror and stops down the lens. The shutter can then be released with vibration reduced to a minimum.

The viewfinder illumination is another feature reintroduced from an earlier camera, in this case the SL2. It is better than the SL2, however, as the aperture and shutter speed read-out are illuminated. This is a very valuable facility when working in dark surroundings, eg a theatre.

Like the M6, the R6 is a tough reliable tool for capable, thinking photographers. In some ways it is more demanding than the R5 or the R-E, but for those who wish to be in control it is in fact easier to work with.

R-E, A SIMPLIFIED R5

The R-E is in effect an R5 without shutter priority and programme modes. All other features of the flagship camera are retained, including TTL flash and full lens and accessory compatibility. Many photographers are well satisfied to work with just manual and aperture-priority auto modes. These features together with the options of averaging and spot metering ensure that the R-E is a fully effective professional tool available at a worthwhile cost saving compared with the R5.

LEICA 'R' LENSES

Leica lenses are legendary. The success of the Ernst Leitz company as the pioneer of 35mm photography owed much to the remarkable quality of the early Elmars and Hektors – a tribute to the manufacturing techniques developed for the production of microscopes and to the design skills of Max Berek. The reputation has been maintained and, as one respected American technical writer put it, 'If the only reason you buy a Leica is to be able to use those superb lenses, it is worth it.'

Leica was amongst the first to use electronic computers to aid lens computation. It also realised the importance of being able to incorporate special types of optical glasses and in the late 1940s it established its own laboratory in order to develop these. From this laboratory came the glasses that gave designers the ability to produce such landmark lenses as the 50mm f2 Summicron of 1953, the 180mm f3.4 Apo Telyt of 1975, and the 50mm f1 Noctilux of 1976. More recently the 280mm f2.8 Apo Telyt and the 100mm f2.8 Apo Macro Elmarit have set new standards of performance in their categories.

All Leica lenses are engineered to the very highest standards. This ensures long life under the most arduous conditions and with hard professional use. High optical performance can only be maintained with equivalent mechanical build quality, so as to retain correct centration of lens elements, smooth focussing, and correct operation of auto diaphragms with accurate linkages of cams and levers to the camera body. Attention to detail is exemplified by the inclusion of built-in telescopic lens hoods wherever practicable. Lenses without built-in hoods (the 21/4, 24/2.8, 28/2.8, the PC lenses and the 800/6.3) are supplied as standard with an efficient clip-on or screw-on type.

The currently available system (see table A overleaf) comprises thirty-four lenses in focal lengths from 15mm to 800mm, with a choice of lens speed in the most popular part of the range. Some current lenses are completely new versions of earlier ones of similar focal lengths and apertures. The table on p145 lists the discontinued lenses and serial numbers at which designs were changed. From time to time there have also been cosmetic changes (eg to filter sizes or to incorporate built-in lens hoods), which are also noted in the table.

It has always been possible, with appropriate adapters, to use lenses originally intended for the Leica 'M' Visoflex reflex housings. A serious disadvantage is that these do not have the automatic stop-down diaphragm of the 'R' lenses and after focussing they need to be stopped down manually. Nevertheless, there are some interesting lenses in this group whilst some of them (the 400, 560, and 800mm Telyts) are identical with the 'R'

equivalents except for the bayonet mount. Most of the older 'M' or screw-mount lenses of 90mm focal length or longer had a 'Viso' adapter.

The table on p146 lists some of the more useful combinations only with those lenses specifically produced for the reflex housings. The key adapter from Visoflex mount to Leica 'R' is the 14167.

Mention should be made of the Photar lenses. These are specially computed for photography where the image on the film is to be larger than lifesize. The three lenses cater for ranges of magnification up to 16× and are designed to be used with the 'R' bellows unit. They too do not have an automatic diaphragm and have to be manually stopped down.

The range of thirty-four lenses is not a challenge to collect a full house but an opportunity for the photographer to tailor an outfit to his particular needs, whether in terms of focal length, lens speed or specialised requirements met by, for example, macro or perspective control lenses.

All Leica lenses will give excellent image quality at maximum aperture. All lenses improve on stopping down but the optical quality of Leica lenses is such that, starting from a very high level of performance at full aperture, even with f1.4 and f2 lenses quite outstanding quality is available by f4. With slower lenses optimum results will be achieved by closing down no more than one stop, and with the Apo lenses and some of the longer telephotos even this is unnecessary. Most lenses have their corrections optimised for subjects at greater distances (macro lenses are an exception) and, especially with the wider aperture or wide-angle designs, it may be desirable to stop down for best quality at distances closer than 1.5 to 2m.

STANDARD LENSES

Lenses around 50mm focal length approximate closely to the angle of view of the human eye and, therefore, give natural perspective. They are thus very versatile and most cameras are bought with a standard lens – usually the 50mm Summicron.

50/2 SUMMICRON

First-class optical performance at all apertures in both the near and far ranges. Fast enough for almost any kind of subject, light, compact and very economically priced.

50/1.4 SUMMILUX

Also very good optically, relatively light and compact, but the penalty for a one-stop increase in speed is less good performance at nearer distances and a very considerable increase in price.

60/2.8 MACRO ELMARIT

A slightly longer focal length but still classed as a standard lens. Exceptionally versatile, focussing to half lifesize unaided and to lifesize with the Macro Adapter. Excellent optical performance at all apertures and throughout its entire focussing range. Still fairly light but not quite as compact as the 50/2 and 50/1.4. Slower than the other two lenses but if your outfit includes other f2 or f1.4 lenses, eg a 35 or 80/90, this is a very logical choice.

TABLE A LEICA REFLEX LENSES

LENS	Maximum aperture/Focal length in mm	Angle of view	Number of elements/ components	Smallest aperture	Focussing range in m	Smallest object area in mm	Filter size series	Length in mm	Diameter in mm	Weight in g	Code
SUPER-ELMAR-R	f/3.5/15	110°	13/12	22	∞ – 0.16	70x106	Built in	92.5	83.5	815	11213
FISHEYE-ELMARIT-R	f/2.8/16	180°	11/ 8	16	∞ – 0.30	401x601	Built in	60	71	470	11222
ELMARIT™-R	f/2.8/19	96°	12/10	22	∞ – 0.30	264x396	Built in	60	71	500	11258
SUPER-ANGULON™-R	f/4/21	92°	10/ 8	22	∞ – 0.20	148x221	Series 8.5	43.5	78	410	11813
ELMARIT-R	f/2.8/24	84°	9/ 7	22	∞ – 0.30	250x374	Series 8	48.5	67	420	11221
ELMARIT-R	f/2.8/28	76°	8/ 8	22	∞ – 0.30	188x282	Series7	40	63	275	11247
PC SUPER-ANGULON™-R	f/2.8/28	73/93°	12/10	22	∞ – 0.28	146x219	special filter 67 EW	84	75	565	11812
SUMMILUX™-R	f/1.4/35	64°	10/ 9	16	∞ – 0.50	266x399	E 67	76	75	660	11143
SUMMICRON™-R	f/2/35	64°	6/ 6	16	∞ – 0.30	140x210	E 55	54	66	422	11115
ELMARIT-R	f/2.8/35	64°	7/ 6	22	∞ – 0.30	140x210	E 55	41.5	66	305	11251
PA-CURTAGON™-R	f/4/35	64/78°	7/ 6	22	∞ – 0.30	140x210	Series 8	51	70	290	11202
SUMMILUX-R	f/1.4/50	45°	7/ 6	16	∞ – 0.50	180x270	E 55	50.6	66.5	395	11777
SUMMICRON-R	f/2/50	45°	6/ 4	16	∞ – 0.50	180x270	E 55	41	66	300	11216
MACRO-ELMARIT-R	f/2.8/60	39°	6/ 5	22	∞ – 0.27 (with adapter to 1:1)	48x72 (24x36)	E 55	62.3 (92.3)	67.5	390 (520)	11253
SUMMILUX-R	f/1.4/80	30°	7/ 5	16	∞ – 0.80	192x288	E 67	69	75	625	11881
SUMMICRON-R	f/2/90	27°	5/ 4	16	∞ – 0.70	140x210	E 55	61	69	595	11254
ELMARIT-R	f/2.8/90	27°	4/ 4	22	∞ – 0.70	140x210	E 55	57	67	475	11154
APO-MACRO-ELMARIT-R	f/2.8/100	25°	8/ 6	22	∞ – 0.45 (with ELPRO 1:2–1.1:1)	48x72 (22x33)	E 60	104.5	73	790	11210
MACRO-ELMAR-R	f/4/100	25°	4/ 3	22	∞ – 0.27 (with adapter to 1:1.6)	72x108 (38x57)	E 55	90 (120)	67.5	540 (670)	11232
MACRO-ELMAR	f/4/100	25°	4/ 3	22	focussing bellows only ∞ – 1:1	24x36	E 55	62.5	68	365	11230
ELMARIT-R	f/2.8/135	18°	5/ 4	22	∞ – 1.50	220x330	E 55	93	67	730	11211
ELMARIT-R	f/2.8/180	14°	5/ 4	22	∞ – 1.80	193x290	E 67	121	75	825	11923
APO-TELYT-R	f/3.4/180	14°	7/ 4	22	∞ – 2.50	276x414	E 60	135	68	750	11242
ELMAR™-R	f/4/180	14°	5/ 4	22	∞ – 1.80	175x262	E 55	100	65.5	540	11922
TELYT™-R	f/4/250	10°	7/ 6	22	∞ – 1.70	124x186	E 67	195	75	1230	11925
APO-TELYT-R	f/2.8/280	8.5°	8/ 7	22	∞ – 2.50	195x293	E 112	261	125	2750	11245
TELYT-R	f/4.8/350	7°	7/ 5	22	∞ – 3.00	171x257	E 77	286	83.5	1820	11915
TELYT-R	f/6.8/400	6°	2/ 1	32	∞ – 3.60	158x236	Series 7	384	78	1830	11953
APO-TELYT-R	f/2.8/400	6°	11/ 9	22	∞ – 4.70	220x330	Series 5.5	353	178	7000	–
MR-TELYT-R	f/8/500	5°	5/ 5	8	∞ – 4.00	180x270	(E 32) 5 filters available	121	87	750	11243
TELYT-R	f/6.8/560	4.3°	2/ 1	32	∞ – 6.40	224x336	Series 7	530	98	2330	11853
TELYT-S	f/6.3/800	3°	3/ 1	32	∞ – 12.50	320x480	Series 7	790	152	6860	11921
VARIO-ELMAR-R	f/3.5/4.5 28–70	76–35°	11/ 8	22	∞ – 0.50	336x504 144x216	E 60	74.5	74.8	468	11265
VARIO-ELMAR-R	f/3.5/35–70	64–35°	8/ 7	22	∞ – 1.00	632x947 338x507	E 67	66.5	76.5	450	11248
VARIO-ELMAR-R	f/4/70–210	35–12°	12/ 9	22	∞ – 1.10	264x396 96x144	E 60	157	73.5	720	11246

NORMAL WIDE-ANGLE

For most photographers the 28 or 35mm medium wide-angle is one of the most used focal lengths. Combined with a short telephoto (80 or 90mm) or a 70/210 zoom it will cover a very high proportion of general photographic requirements.

28/2.8 ELMARIT

The lightest and most compact Leica 'R' lens. Excellent performance at all apertures at normal distances but requires stopping down to f5.6 or f8 for critical edge detail when focussed closer than 1.5m. Minor disadvantages are non-standard filter size and separate lens hood. If you only have one wide-angle lens this should be it.

35/2.8 ELMARIT

Although the slowest of the 35mm focal length lenses, overall optical performance is excellent. Should be stopped down to f5.6/f8 if critical edge detail is required at distances closer than 1m. Light and reasonably compact, economically priced.

35/2 SUMMICRON

Best all-round 35, fast enough for almost any need. First-class optical performance even at full aperture and over the entire focussing range. Reasonably compact and fairly light.

35/1.4 SUMMILUX

The penalty for a one-stop increase in speed is a considerable increase in bulk and weight. Very expensive too, but if you need f1.4 this lens gives first-class optical performance with excellent freedom from flare.

35/4 PC CURTAGON AND 28/2.8 PC SUPER ANGULON

Those needing a perspective control lens for architectural or studio photography will find the recently introduced 28mm a much

WELLS CATHEDRAL
The new 28/2.8 PC Super Angulon provides a usefully wide angle of view together with an unusually extended amount of shift. The effect of using a PC lens is clearly demonstrated in this view of a well-known English cathedral. The first picture was taken with no shift and the second with the maximum 11mm, allowing full correction of the converging verticals. The plain screen with grid lines is a great help in aligning the verticals.

Leica R5, 28/2.8 PC Super Angulon, 1/60 f8 Kodachrome 25 Professional

28/2.8 PC SUPER ANGULON
The 28mm f2.8 PC Super Angulon is a first-class lens specially intended for architectural and studio photography. Seen here mounted on a Leica R6 with the lens displaced vertically by the maximum 11mm

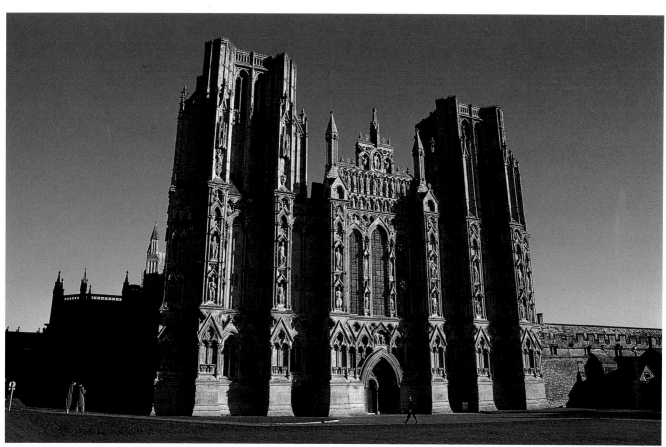

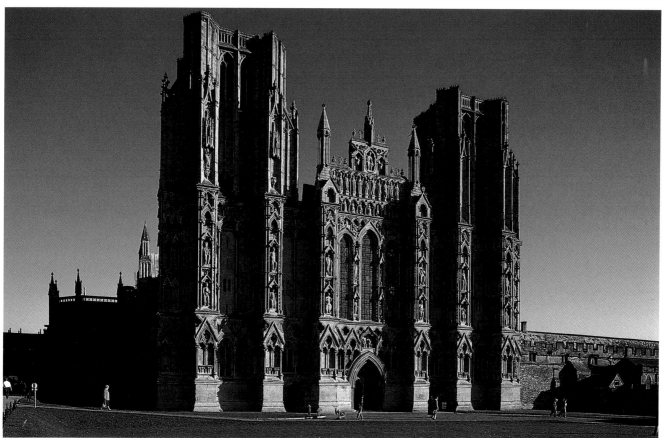

better lens than the older 35mm. The wider angle is obviously valuable but there are other advantages – a greater amount of shift and superior optical performance. The field is very flat and there is minimal distortion. Even with maximum shift, first-class definition over the whole field is achieved between f8 and f11. It is not practicable to incorporate an auto diaphragm in a PC lens and in each case it is necessary to set the lens to the working aperture before exposure. Both lenses are produced to Leica specifications by Jos Schneider, Kreuznach.

ULTRA-WIDE-ANGLE

Ultra-wide-angle lenses not only enable the photographer to work in a constricted space but allow him to exploit their facility for dramatic perspective effects. Practice is needed to spot unplanned converging verticals and to avoid areas of blank foreground, but the results can be spectacular.

15/3.5 SUPER ELMAR

Lens based on a Zeiss design. Incredibly wide angle for a rectilinear (non-fisheye) design. Very bulky, very heavy, but if you need it it's splendid. Built-in UVa, orange, yellow and blue (conversion) filters.

16/2.8 FISHEYE ELMARIT

Minolta lens built to Leica specifications. Excellent performance with a full-frame picture, not too bulky. Built-in UVa, orange, yellow and blue (conversion) filters. The 180° angle of view allows some unique effects. With care the edge curvature characteristics of fisheye lenses can be minimised.

19/2.8 ELMARIT

This lens was redesigned and introduced at Photokina 1990. As well as being optically superior, this latest version is much more compact than its predecessor. Like the 15/3.5 and the 16/2.8 Fisheye it has four built-in filters – orange, yellow, blue and ND.

19/2.8 ELMARIT
The new 19mm f2.8 Elmarit introduced at Photokina 1990. It incorporates floating elements to maintain corrections in the near focus range and features built-in filters

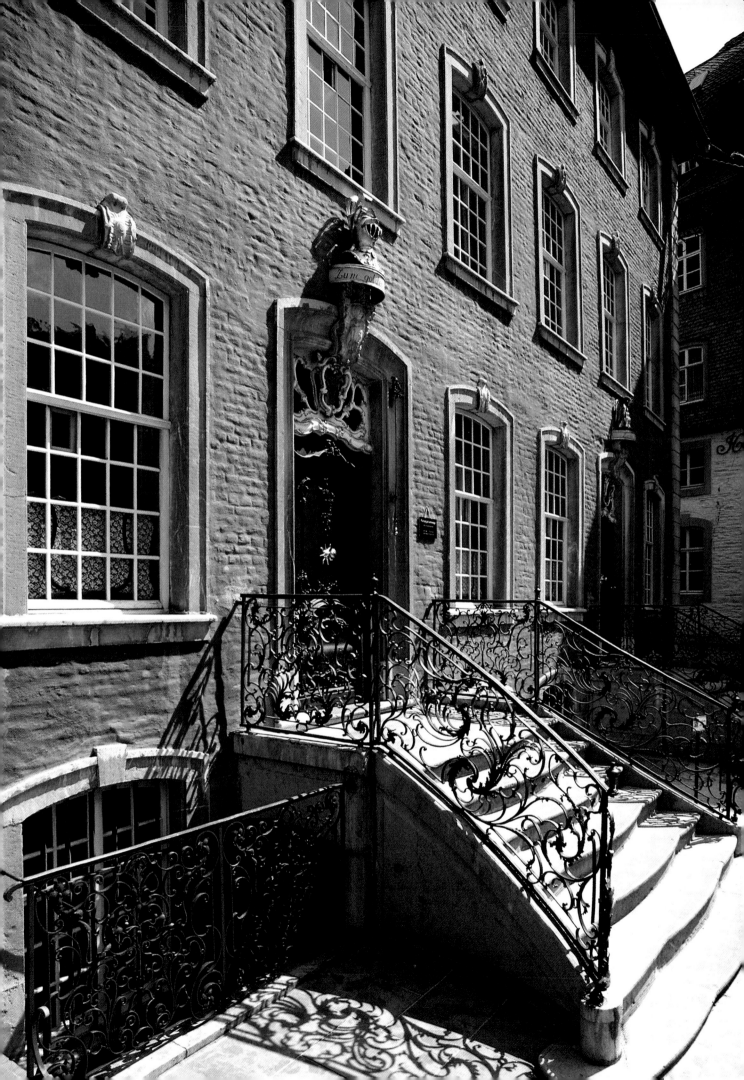

Previously most Leica photographers have preferred the 21mm to the 19mm but the advantages of this new design may well change their opinion. Floating elements are used for improved corrections in the near distance range.

21/4 SUPER ANGULON

Despite the slow f4 maximum aperture this is probably the best all-round ultra-wide. Relatively compact, optically excellent, with particularly useful close focussing. For very critical edge definition it requires to be stopped down to f8.

24/2.8 ELMARIT

Another Minolta design. A very good performer, also with floating elements but a rather 'in between' focal length.

MID-RANGE TELEPHOTO

A 'short tele' is an essential in any photographer's armoury of lenses. It encourages concentration on the essentials of the picture and if one of the wider aperture designs is chosen it makes an excellent general-purpose lens for use even in poor lighting conditions. An 80 or 90 combined with a 28 or 35 can eliminate the need for a standard (50mm) lens. When or whether to go for a longer focal length requires more thought.

80/1.4 SUMMILUX
A cross-section of the
80mm f1.4 Summilux

80/1.4 SUMMILUX

Very fast lens, not too bulky, with good freedom from reflections so that it is ideal for available-light photography. At greater distances optical performance is very good even at f1.4, but at closer distances – say under 1.5m – it needs to be well stopped down (say to f5.6/f8) to maintain the highest performance. Heavier than the 90mm lenses and cannot be used for close-up work with Elpros.

90/2 SUMMICRON

Classic short telephoto. The maximum aperture of f2 is fast enough for most requirements. The lens gives excellent quality at all apertures and in the near focus range. Compact, not too heavy

GRAND CANYON
A fast medium telephoto lens is an extremely valuable addition to any outfit. The 90/2 Summicron is one of my favourite general-purpose lenses. This winter shot was taken from the South Rim when cloud cleared briefly. Well-known scenes require 'different' light and weather to make interesting pictures.

Leica R4, 90/2
Summicron
Kodachrome 64
Professional

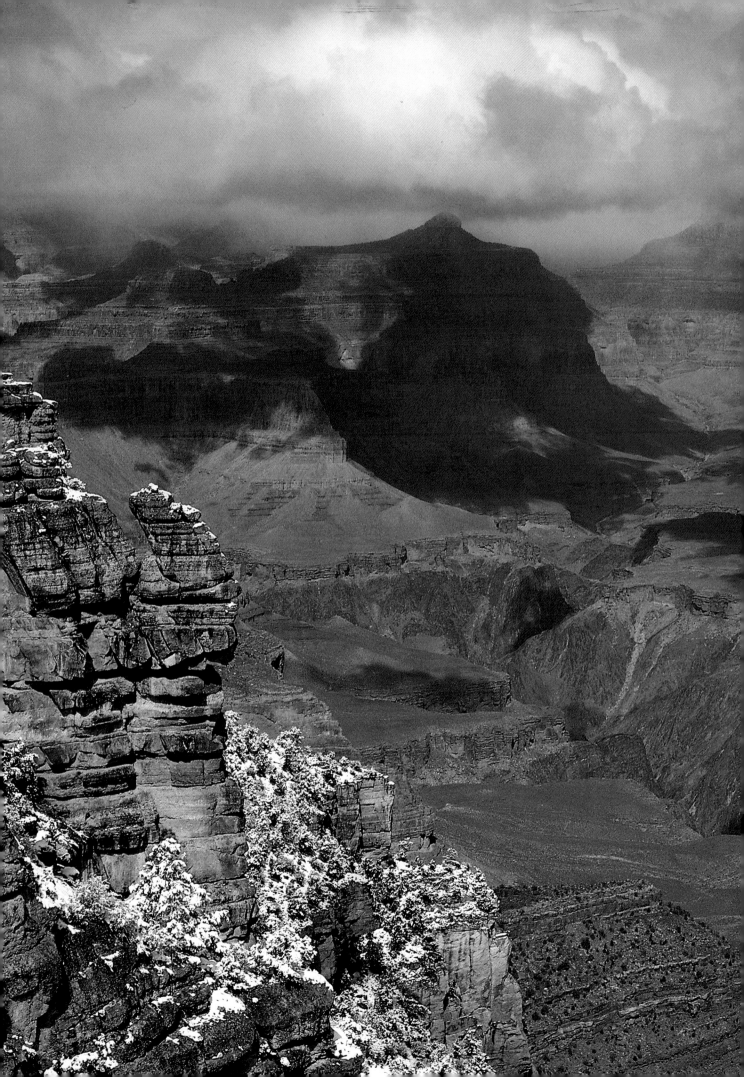

and accepts many standard accessories, including the Elpro close-up lenses which provide excellent close-up quality.

90/2.8 ELMARIT

Extremely good optically. This is a first-class medium tele that also accepts many standard accessories, including the Elpros. Very economically priced.

100/4 MACRO ELMAR

Available either in a focussing mount or as a lens head only for the bellows unit. Very useful focal length for close-up photography, particularly of insects and small plants. Very good quality even at maximum aperture; a very flat field and no visible distortion.

100/2.8 APO MACRO ELMARIT

An outstanding lens not only for close-up photography but also as a normal medium telephoto for landscape or portrait work. Especially good for technical illustrations. Bulkier and heavier than the 90s. Focuses to half lifesize unaided and to slightly over lifesize (1.1:1) with its own special Elpro lens. Cannot be used with the Macro Adapter.

135/2.8 ELMARIT

The classic 135 tends to be something of an 'in between' focal length these days. Nevertheless, the current design is a first-class performer even wide open at f2.8. Works well with the 2× extender.

180/4 ELMAR

Actually lighter and more compact than the 135. Very good performance – also good with 2× extender. Good close focussing ability with the Elpro attachments.

180/2.8 ELMARIT

Remarkably light and compact for its speed and focal length, with excellent performance at all apertures. Less good with 2× extender than the 180/4 and 180/3.4 Apo.

180/3.4 APO TELYT

The first Leica Apo lens, originally developed under a defence research contract. Superb performance, best of the 180s and best with the 2× extender, but lacks the near focussing ability of the other 180s and is less compact.

THE LONGER TELEPHOTO

The Leica 'R' programme includes eight lenses from 250 to 800mm focal length. Choice within this range has to be much more precisely related to the photographer's personal requirements than in any other group. An extra stop or two of speed adds enormously to size, weight and cost. There is no doubting the fascination of the long lens image and for sport and wildlife photography the lenses are essential. Nevertheless, my advice to the photographer is to consider his or her needs very carefully and it may be that a 180 plus 2× extender will be a better solution for occasional use. If at all possible, actually handle the different

BARGE ON THE MOSEL, BERNKASTEL
These two pictures of this one barge, taken from the same position, demonstrate the effect of focal length on perspective. The first picture was taken with the 90/2 Summicron lens when the barge was some distance away. The second, taken just before the barge passed under the bridge where I was standing, was done with the 21/4 Super Angulon. Although the vessel is approximately the same size in each picture, note how the different lenses control the amount of landscape included in the composition.

Leica R5, 90/2 Summicron, 1/500 f4/f5.6 and 21/4 Super Angulon 1/125 f8 Kodachrome 64 Professional

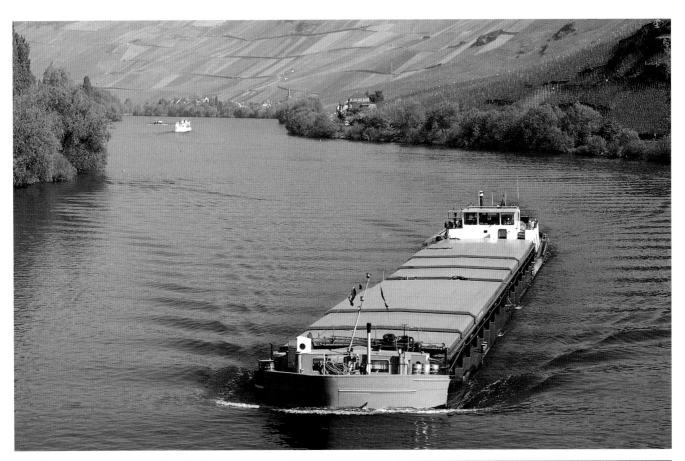

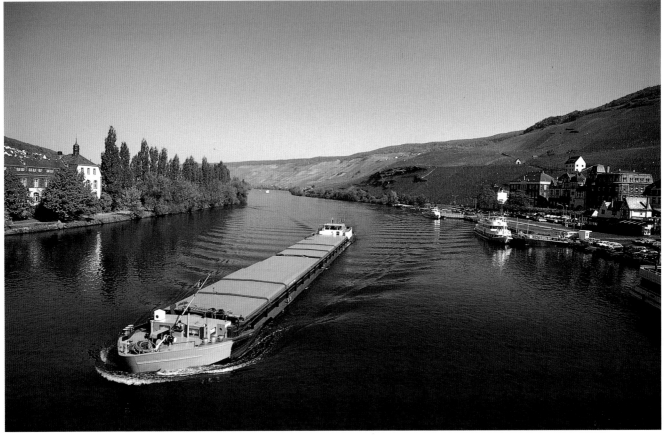

lenses – focussing and a comfortable hold to help avoid camera shake are vital for sharp results. These long Leica lenses have excellent ergonomic design features but people vary (a lot!) and a practical test is highly desirable.

250/4 TELYT

Very good optically, fairly compact and very comfortable handling. If you already have a 180 (or the 70/210 zoom) the extra reach, in my opinion, is not sufficient to be worthwhile. Works quite well with the 2× extender giving a useful 500 f8.

280/2.8 APO TELYT

Big, heavy and absolutely magnificent. Performance at f2.8 is superb, go down a stop and incredibly it gets even better. Excellent performance is maintained with the matched 1.4× Apo extender (giving a 400mm f4 lens) and is very good with the 2× (giving a 560mm f5.6). Despite the weight, handling with the palmgrip supplied is excellent and the internal focussing system makes this easy and comfortable.

350/4.8 TELYT

A very similar design to the 250. This lens is relatively light and compact for its speed and focal length. Good optically, and handles well.

400/6.8 TELYT

Despite its limited maximum aperture this has been a classic long focus design for many years. Relatively light and portable (it separates into two for easy storage), with excellent optical quality and quick easy handling with or without the universal handgrip supplied, are the attributes that have made this a favourite for many wildlife photographers. Improvements in the quality of faster colour films have now pretty well overcome the speed restriction of the f6.8 aperture.

400/2.8 APO TELYT

Following the outstanding success of the 280/2.8 Apo Telyt, especially with sports photographers, several prototypes of this new longer lens were produced for use at the 1988 Olympics and it was shown at Photokina 1988. Further development has resulted in revisions to both optical and mechanical design. The production version is expected to be available in 1991. Details in Table A (p23) relate to the prototype.

500/8 REFLEX

A mirror lens produced for Leica by Minolta. Amazingly compact and portable for its focal length, with good optical performance. In common with all mirror designs it suffers from a very dim viewfinder image and the lack of any aperture control system. Exposure can be controlled only by varying shutter speed or using neutral density filters. For the above reasons it is not easy to focus accurately or to avoid camera shake.

560/6.8 TELYT

Big brother of the 400 f6.8. Obviously much less compact and

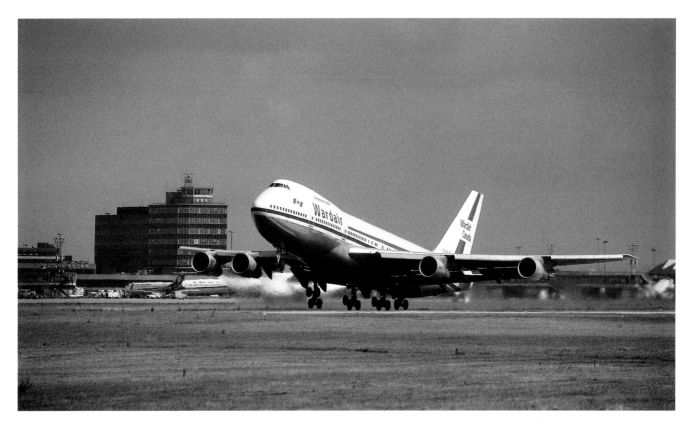

certainly not nearly so successful for handheld general-purpose use. Optical quality excellent.

800/6.3 TELYT S

A highly specialised lens. The optical quality is superb but bulk and weight are enormous. A massive tripod is required and a team of assistants is practically a necessity!

ZOOM LENSES

The great advantage of a zoom is that one lens provides a range of focal lengths. This means less to carry around and gives the facility to compose pictures very precisely. The disadvantages are that in order to keep weight and bulk within practical limits, these lenses are relatively 'slow' with limited maximum apertures. Also, due to the necessarily very complicated optical construction, performance is technically inferior to that of a top-class prime lens. In practice, however, the Leica zoom lenses are of such quality that it is only by direct comparisons under the most critical conditions that the superiority of the prime lens is apparent.

28–70 f3.5/4.5 VARIO ELMAR

Another lens introduced at Photokina 1990. Light, compact and offering a usefully wider angle than the well-tried 35–70. Other advantages are macro focussing giving a 1:6 maximum image size, and a more convenient filter size. The main disadvantage is that the maximum aperture reduces with increasing focal length, becoming f4.5 at 70mm. As with the 35–70 there are separate controls for focussing and adjusting focal length.

747 TAKE-OFF
The quality of the 280/2.8 Apo lens is legendary. For sports, action and wildlife photography the wide aperture allows the use of slower, high-quality films or working in low-light situations. Here the camera has caught the precise moment when this huge airliner becomes airborne.

Leica R4 (with motor drive)
280/2.8 Apo Telyt 1/1000 f2.8
Kodachrome 64 Professional

33

35–70 f3.5 VARIO ELMAR

For many walkers, climbers and others wishing to minimise weight and bulk, this lens makes an ideal combination with the 'R' camera. Very good performance from Leica mechanical and Minolta optical design. Limited close focussing ability, not suitable for use either with the extender 'R' or the Macro Adapter.

70–210 f4 VARIO ELMAR

Another Minolta-based design. One of the finest zooms available in this range, with virtually no distortion at either end of the zoom, excellent sharpness and the full f4 aperture available at 210mm. Good close focussing ability which will give an image of one quarter lifesize at the 210mm setting. Combine this lens with a 28 or 35mm wide-angle and you have a splendidly lightweight and versatile outfit. Not suitable for use with Macro Adapter, and performance with the 2× extender is marginal by Leica standards.

EXTENDERS

The Leica extenders are a convenient way of increasing the focal length of lenses, albeit with a significant loss of speed – two stops in the case of the 2× and one stop for the 1.4×. The optical quality of the combination depends on the quality of the prime lens and the efficiency of the 'match'.

1.4× EXTENDER

This was specifically designed for use with the 280 Apo lens and is carefully matched to maintain the Apo corrections. In this respect it succeeds superbly and the combination, which produces a 400mm f4, is as stunning as the 280 itself. Be warned that the 1.4× cannot be used with most other lenses, because its front elements protrude into the rear of the prime lens and in most cases would damage the latter's rear elements. The 1.4× extender cannot be used on SL2 and earlier models. It can be used in all operational modes on R4 and R5 cameras.

2× EXTENDER

Works satisfactorily with lenses from 50mm upwards, other than the zooms and the 80/1.4. f2 lenses need to be stopped down to at least f2.8. The lenses that work particularly well are the 135/2.8, the 180s, particularly the 180 Apo, the 280/2.8 and the 400/6.8. For those who insist on ignoring the manufacturer's recommendations the 2× plus the 70/210 zoom gives results that are acceptable, although not to standards that Leica approves!

There are two versions of the 2× extender. One fits the R3 and later cameras only, and provides full aperture metering and aperture priority auto operation as well as manual. The other fits all models including the SL2 and earlier cameras, but provides working aperture operation only.

THE ROYAL YACHT BRITANNIA AT COWES There are many occasions when the position of the subject and how close you can get to it are unpredictable. A zoom lens is a great help to getting frame-filling pictures.

Leica R5, 70/210 Vario Elmar 1/500 f4 Fuji Velvia

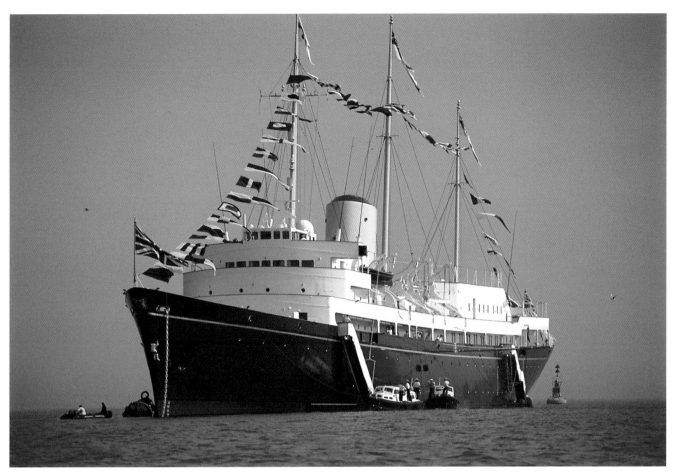

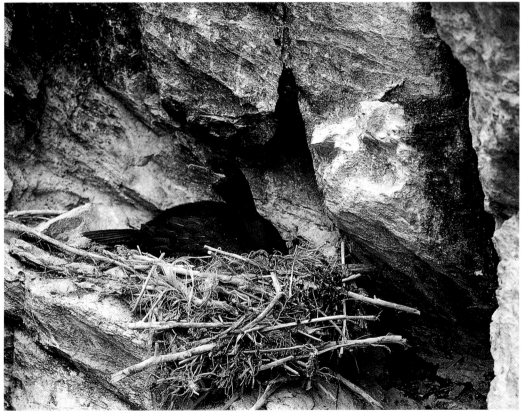

SHAG ON NEST, BASS
ROCK
The 2× extender is a
very convenient and
effective way of
providing a long
telephoto lens. With
faster films the loss of
two stops of light is
tolerable. It works
particularly well in
combination with the
180/3.4 Apo Telyt
giving an effective
360mm f6.8 lens.

Leica R6, 180/3.4
Apo Telyt plus 2×
extender, 1/500 f3.4
(equal to 360/6.8)
Kodachrome 200
Professional

LEICA REFLEX LENSES

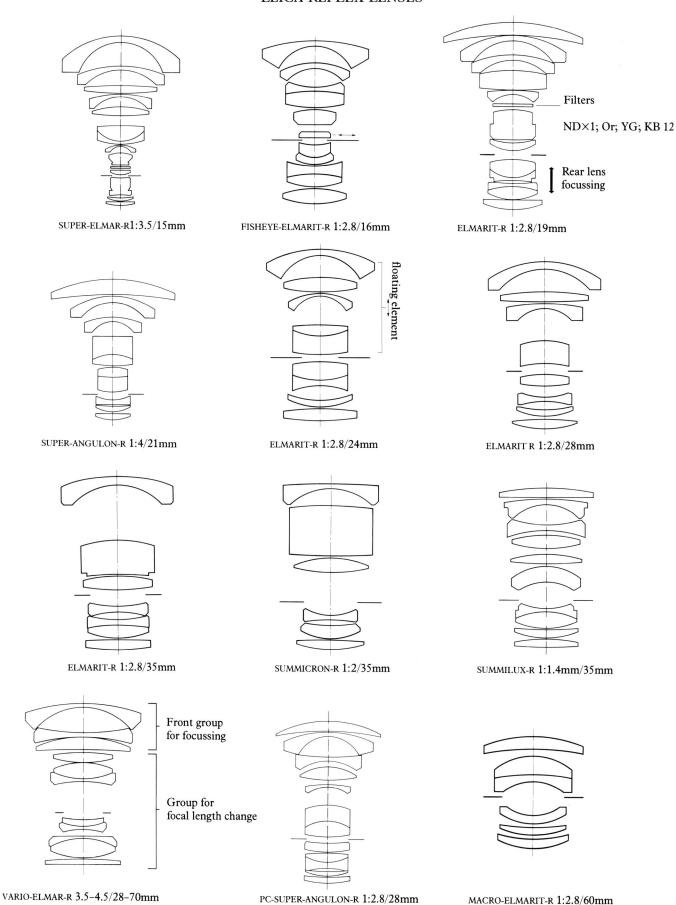

SUPER-ELMAR-R1:3.5/15mm

FISHEYE-ELMARIT-R 1:2.8/16mm

ELMARIT-R 1:2.8/19mm

Filters

ND×1; Or; YG; KB 12

Rear lens focussing

SUPER-ANGULON-R 1:4/21mm

ELMARIT-R 1:2.8/24mm

floating element

ELMARIT R 1:2.8/28mm

ELMARIT-R 1:2.8/35mm

SUMMICRON-R 1:2/35mm

SUMMILUX-R 1:1.4mm/35mm

VARIO-ELMAR-R 3.5–4.5/28–70mm

Front group for focussing

Group for focal length change

PC-SUPER-ANGULON-R 1:2.8/28mm

MACRO-ELMARIT-R 1:2.8/60mm

LEICA REFLEX LENSES

SUMMILUX R 1:1.4/50mm

SUMMICRON-R 1:2/50mm

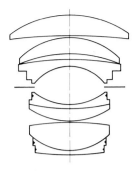

SUMMILUX-R 1:1.4/80mm

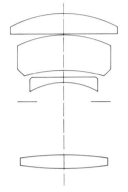

ELMARIT-R 1:2.8/90mm

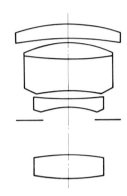

SUMMICRON-R 1:2/90mm

MACRO-ELMAR 1:4/100mm

APO-MACRO-ELMARIT-R 1:2.8/100mm

ELMARIT-R 1:2.8/135mm

ELMAR-R 1:4/180mm

APO-TELYT-R 1:3.4/180mm

ELMARIT-R 1:2.8/180mm

TELYT-R 1:4/250mm

37

LEICA REFLEX LENSES

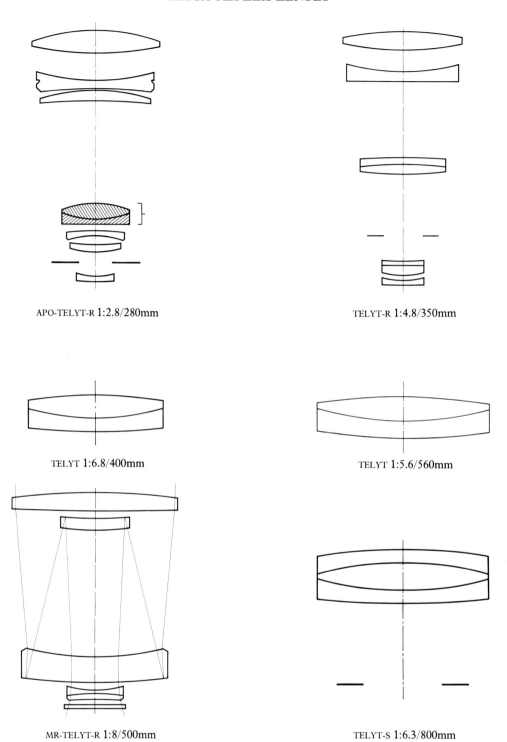

APO-TELYT-R 1:2.8/280mm

TELYT-R 1:4.8/350mm

TELYT 1:6.8/400mm

TELYT 1:5.6/560mm

MR-TELYT-R 1:8/500mm

TELYT-S 1:6.3/800mm

GETTING MAXIMUM SHARPNESS

The Leica and its lenses are capable of producing images of outstanding quality. To realise this quality consistently involves a little care and some practice but the results are worth the trouble.

ACCURATE FOCUSSING

Perhaps it sounds too obvious, but the first essential for a sharp picture is accurate focussing. In practice there are many situations where a reflex camera is not at all easy to focus accurately. Typically, problems occur when working with wide-angle lenses or in poor light. Also, with the standard split image/microprism focussing screen there will usually be difficulties when focussing with slower long lenses and when working close up. Even with faster teles the split image rangefinder spot cannot be relied on for absolute accuracy, as this demands that the eye be perfectly centred with the finder. For critical work it is safer to focus on the microprism 'doughnut' or the outer plain area of this screen.

In poor light and with wide-angles the only answer is to recognise that there is a definite problem and to take extra care. A quick check on the focussing scale will sometimes reveal obvious errors and scale focussing is often the best method with ultra-wides used at longer distances.

With slower lenses, macro lenses and longer teles, the plain screen with or without the grid is recommended. It may be slightly less bright overall but focussing will be much more precise. The all-microprism is a good practical alternative for the faster telephotos.

It is worth mentioning that precise focussing demands good eyesight. Many people have defects in their vision that may be of little consequence in the normal course of events but may be critical to the handling of a camera. Apart from astigmatism and other defects which require proper correction, it is a fact that from around age forty-seven onwards, everybody finds near focussing progressively more difficult. The image on a Leica Reflex screen is, in effect, set at about 1m and you need to be able to see clearly at this distance. If necessary you should wear spectacles or fit a correction lens to the viewfinder eyepiece to enable you to do this comfortably, otherwise you will never focus your camera accurately. Leica offers a range of correction lenses for the viewfinder so there is generally an easy answer to the problem.

Do not rely on depth of field to cover focussing errors. At close

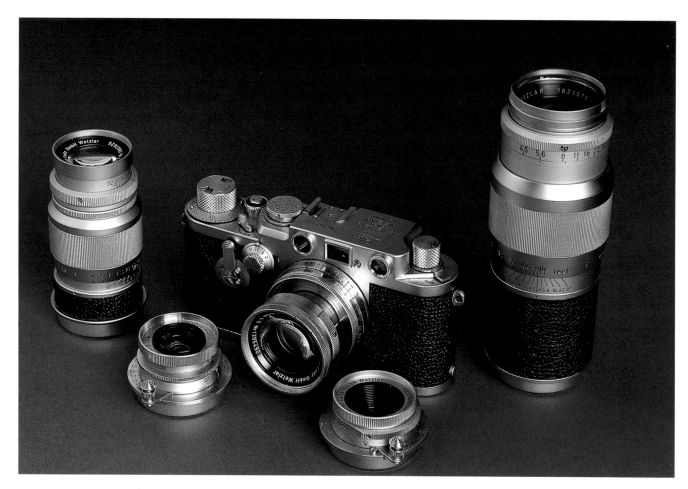

LEICA 111F OUTFIT
Slow film, a solid tripod, accurate focussing and careful placement of the point of focus to obtain maximum depth of field are all essential for biting sharpness with close-up studio-type illustrations. The plain screen (preferably with grid) is best for this kind of work as overall sharpness can be examined using the camera's stop-down lever. Window light with white card reflector.

Leica R4, 100/2.8
Apo Macro, 1sec f16
Kodachrome 25
Professional

range even ultra-wides need to be focussed carefully. With more normal focal lengths you should realise just how limited depth of field really is. Take, for example, a typical head and shoulders portrait. Ideally you would use an 80 or 90mm lens and be about 2m from your subject. Your depth of field would be:

f2	50.8mm (2in)
f2.8	69.8mm (2¾in)
f4	88.9mm (3½in)
f5.6	107.9mm (4¼in)
f8	139.7mm (5½in)

Don't forget that the plane of focus is still the sharpest point – depth of field merely indicates the area in which the unsharpness is acceptable!

With distant subjects it is all too easy to fall into the trap of leaving the lens set at infinity. You might get away with this with shorter focal lengths but just look at what happens with, for example, a 180mm lens. Set at infinity and at f4 the nearest point that is acceptably sharp is 243m (800ft) away! Even at f11 the nearest point is 85.3m (280ft).

Long lenses are often used for sports photography. The precise focussing required is not easy on a moving object and a useful technique is to learn prefocussing on a point over which the subject will pass. You will then need to fire the shutter just a fraction

JOHN MORRIS
Depth of field is very limited indeed when working close with longer lenses. The aperture needed here was f2.8 in order to avoid camera shake by using a 1/250sec exposure. The plane of focus is on the eyes but the tip of the nose and the collar are already going out of focus.

Leica R6, 90/2
Summicron, 1/250 f2.8
Fuji Velvia

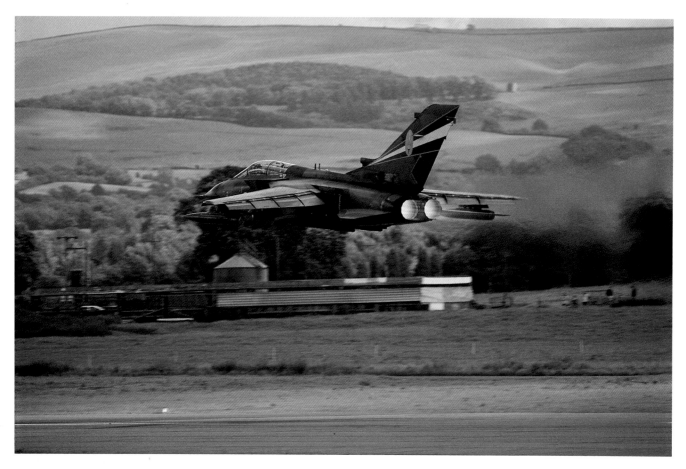

RAF TORNADO
The aircraft was moving at around 320kmph (200mph) just after take-off. With a long lens, focussing is very critical even with more distant subjects. I pre-focussed on the centre line of the runway and panned with the camera as the aircraft went past.

Leica R4 (with motor drive)
280/2.8 Apo Telyt,
1/1000 f2.8
Kodachrome 64 Professional

of a second before the subject reaches the point, so as to allow for the slight delay in your reactions and mirror delay in the SLR.

Some photographers think that it is necessary to get everything sharp in a picture. Sometimes this may be necessary but more often than not an out-of-focus background or foreground will make the sharply defined main subject look even crisper, as well as having added pictorial effect.

CAMERA SHAKE

Without any doubt the biggest single cause of unsharp pictures is camera shake.

Far, far too often photographers use small apertures on their lenses in preference to opening up and using higher shutter speeds. The usual excuses are that lenses are sharper when they are stopped down and that the increased depth of field covers focussing errors. Both arguments are false. Any lens worth its salt should be giving really good performance by the time it is stopped down to f4/f5.6. Leica lenses will give good sharp images even at maximum aperture, be it f1.4, f2 or f2.8, reaching very high standards only one or two stops down. With the longer telephotos a half to one stop down from maximum aperture will be the optimum. To have to stop down to allow for focussing errors is an admission of inadequate technique or laziness! I hope that I have already indicated ways to improve the former.

The conventional wisdom is that the minimum shutter speed for avoiding camera shake is as near as possible to 1/focal length,

eg 1/50 (say 1/60) for a 50mm lens, 1/135 (1/125) for a 135, and 1/28 (1/30) for a 28. In my opinion these speeds are too slow to give consistently shake-free images. My recommendations are tabulated below. Whenever possible use the higher recommended speed.

MINIMUM SPEEDS TO AVOID CAMERA SHAKE

ULTRA-WIDE-ANGLE 15–21mm	1/60
WIDE-ANGLE 24–35mm	1/125
STANDARD 50–60mm	1/125–1/250
MEDIUM TELE 80–135mm	1/250–1/500
LONG TELE 180–250mm	1/500
280–560mm	1/500–1/1000

USING SUPPORT 1 –
TABLE TRIPOD
Table tripod as a support for the 400mm f6.8 Telyt

SUPPORT 2 – BEAN BAG
A 'bean bag' is an excellent way of supporting long lenses to avoid camera shake. Used with the 400/6.8 shown here it allows speeds as slow as 1/125sec to be used safely

SUPPORT 3 – MONOPOD
A Leica 'Tiltall' monopod. The monopod is another aid to steadying the camera for close-up photography or use with long lenses

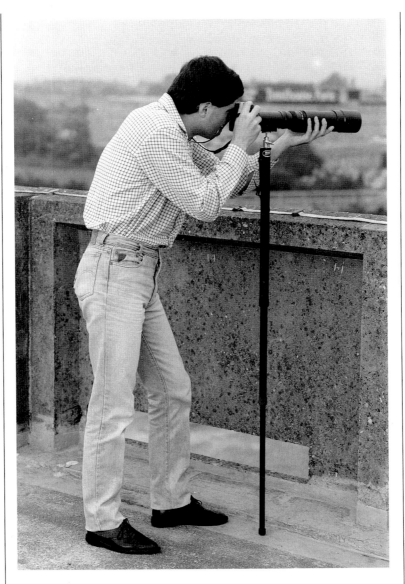

BURG COCHEM, MOSEL
It is vital to avoid camera shake. With longer lenses high shutter speeds are essential when hand-holding the camera. With the 180mm lens used here a speed of 1/500sec is needed and Leica lens quality will allow you to use wide apertures if necessary.

Leica R5, 180/3.4
Apo Telyt, 1/500 f3.4
Kodachrome 64
Professional

Even with the higher speeds a good camera handling technique is required. If you can use some kind of support with the very long lenses you will not only find it easier to avoid shake but also to focus accurately.

The illustrations show various methods. For critical close-ups of static subjects and for other studio work a good tripod is a must, the more rigid and more firmly braced the better. This inevitably means weight, which in itself is no bad thing for damping down vibrations. For field use a smaller, lighter but still rigid tripod is desirable, especially for natural history work. Normally, however, I don't bother with anything other than a small Leitz table tripod. This fits comfortably into my gadget bag and is ideal for use with long teles or for night photography. There are many ways in which it can be used as a direct support or a convenient brace. A useful alternative is a monopod, also light, compact and easy to carry. Very good extra support for most purposes, but not so adequate for long exposures. For long lenses a classic solution is the beanbag which can be placed on any convenient wall, fence etc. The lens is snuggled down on the bag and, with care, speeds

AMERICAN LOCOMOTIVE, PROMONTORY, UTAH
Slow film, good lighting, careful focussing and a shutter speed fast enough to avoid camera shake allow the Leica lens to achieve the outstanding sharpness of which it is capable.

Leica R4, 35/2
Summicron, 1/250 f5.6
Kodachrome 25
Professional

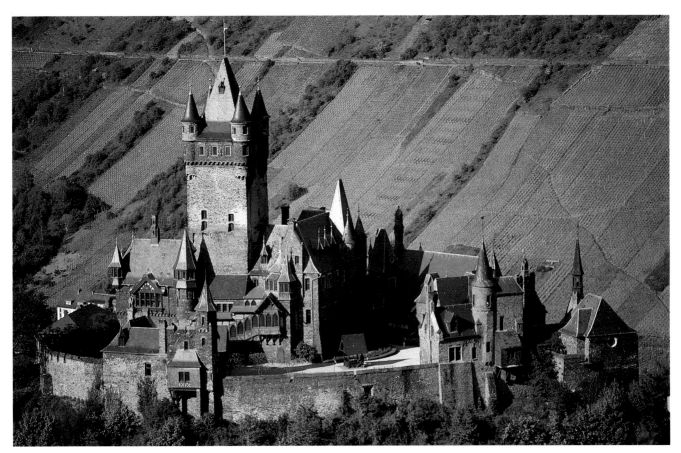

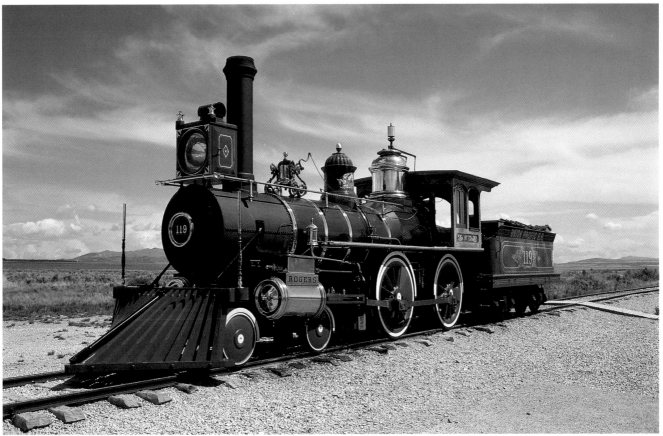

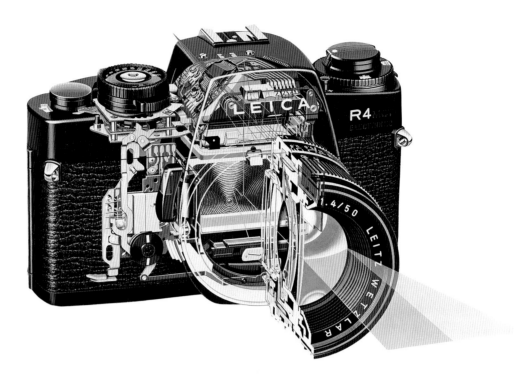

as slow as 1/125 can be used with a 280 or 400.

Even with a tripod (other than perhaps the very heaviest totally rigid types for studio-only use) speeds slower than 1/125 are not very practical with lenses over 250mm. You only need to see how the image wags around when you are focussing to realise that stabilising a long heavy combination is not at all easy.

It is not out of place to refer also to built-in shake. I am referring to the vibrations set up by the mirror as it lifts out of the way at the moment of exposure. In many cameras the only 'brake' is a simple foam strip to cushion the shock, which occurs just as the shutter starts. In Leica Reflexes great care has been taken to minimise this shock and vibration. Details like these add to the cost of a camera but the trouble taken is repaid with much lower levels of vibration and consequently sharper pictures, most particularly at the slower shutter speeds and also in ultra-close-ups. The R6 also allows the mirror to be locked up before making the exposure.

FILM AND EXPOSURE

Choosing the appropriate film and exposing it correctly are obviously vital to good, sharp results. Both topics are dealt with fully in later chapters but the essential points to remember are that, other things being equal, the sharpest results demand slower films. This means films such as Kodachrome 25 or Fuji Velvia for colour, and Kodak Technical Pan, Ilford FP4 or Agfapan 25 for black and white. There will be times, however, when faster films will be needed to allow higher shutter speeds, thereby avoiding camera shake or subject movement, but the rule still is 'Use the slowest film practicable for the job.' Exposure needs to be just right to avoid burning out detail in the highlights or losing it in the shadow areas.

USEFUL ACCESSORIES

There is an enormous range of accessory items available for the Leica Reflex camera. Many of those specific to the camera or its lenses are made by the Leica company itself but there are very many items of more general application, eg filters, tripods, flashguns and camera bags, that are available from a multitude of sources.

Accessories are fun but relatively few last the course to win a permanent place in the outfit. Obviously the choice must depend on the individual photographer's interests but the recommendations below should serve as a useful general starting point.

FOCUSSING SCREENS

From the R4 onwards Leica Reflexes have accepted interchangeable focussing screens. As well as the No 1 standard screen with a split image/rangefinder microprism doughnut as a focus aid, which is normally supplied with the camera, there are four others:

No 2	plain ground glass screen	Code 14304
No 3	all microprism	Code 14305
No 4	plain ground glass screen with grid lines	Code 14306
No 5	clear screen with cross-hairs	Code 14307

All these screens were much improved with a two times increase in brightness at the time that the R4s Mod 2 (or P) and the R5 were introduced. The new screens can be identified by looking at the tongue gripped by the tool for insertion into the camera. The newer screens say R followed by the screen number, whilst the earlier ones say R4 followed by the screen number.

If you have a camera equipped with an older screen it is well worth investing in one of the new ones. Apart from the standard screen the most useful one is undoubtedly the plain ground glass with the grid. Split image and microprism focus aids 'black out' with lenses slower than f4, are not very good with very long lenses and quite useless for close-up photography. For all these purposes the plain ground glass is the best, and it is worth having it with the grid as this is a great help with composition and almost essential for working with the PC lenses and for critical copying. The No 4 screen is now my first preference and three out of the four bodies I use regularly are fitted with it. The fourth body has the standard screen because it is generally used with wide-angle lenses, where the split image rangefinder is a help.

Now that the plain screen is adequately bright the all-microprism screen is needed much less, whilst the clear screen with cross-hairs is primarily for use in scientific applications – astronomical photography or photomicrography.

(LEFT) STANDARD
SCREEN WITH SPLIT
IMAGE RANGEFINDER
SPOT
Good for wide-angle
and fast lenses

(CENTRE LEFT) PLAIN
GROUND GLASS SCREEN
Ideal for use with
slower lenses, long
telephotos and for
close-up photography

(BELOW) PLAIN SCREEN
WITH GRID
All the virtues of the
plain screen with the
advantage of vertical
and horizontal ruling
to allow precise
alignment of the
camera and aid
composition. It helps
especially when
copying and when
working with the PC
lenses

ALL-MICROPRISM
SCREEN
Used as an alternative
to the standard screen
with slower and longer
lenses

CLEAR SCREEN WITH
CROSS-HAIR
For scientific
applications, eg use of
camera on a
microscope

FILTERS

Leica lenses are carefully matched for colour transmission and a special absorban layer is incorporated where necessary to absorb image-degrading ultraviolet. Nevertheless it is good practice to keep a UV or skylight filter on a lens, if only to protect the vulnerable front element from dust, rain, snow or dirty fingers.

Users of black and white film will also find a deep yellow or orange filter useful to control sky tones, whilst for colour the two most useful filters other than the skylight are the circular polariser and the 81b. As well as eliminating reflections from non-metallic surfaces, the polariser allows blue skies to be darkened. The effect is strongest at $90°$ to the angle of the sun and for this reason using a polariser with very wide-angle lenses is not recommended, as the darkening effect will not be even across the frame. In landscape photography the polariser can often be very useful, reducing haze, improving contrast and intensifying colours. The 81b is a warming filter and very valuable for reducing the blueness in photographs taken in open shade or on dull days.

BMW
A graduated grey filter can be very useful to darken pale or overcast skies. Photographing on a rather dull day I was able to give proper exposure for the detail of the car and yet tone down what would otherwise have been recorded as a near-white sky.

Leica R4, 35/2
Summicron, 1/60 f4
Kodachrome 25
Professional

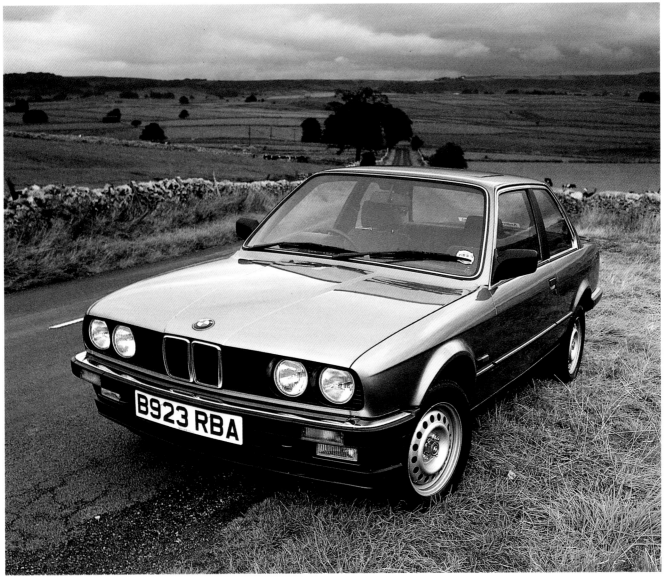

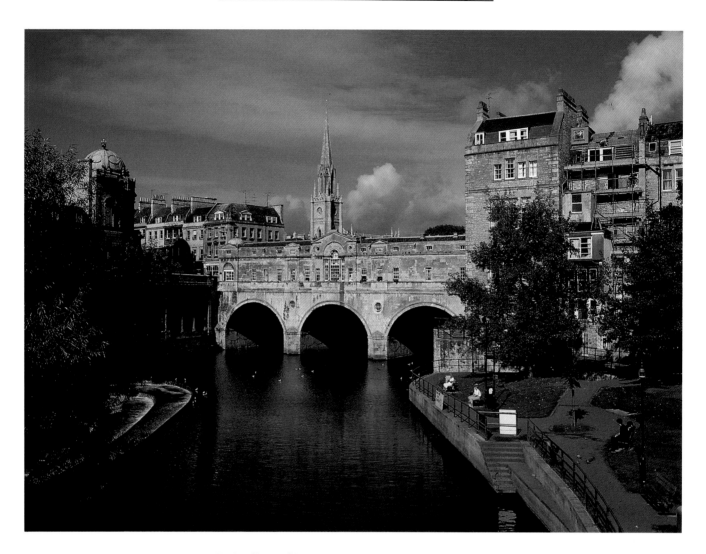

PULTENEY BRIDGE,
BATH
The warm Cotswold
stone of the bridge and
buildings by the Avon
at Bath is set off nicely
by emphasising the
blue sky with the
circular polariser.

Leica R5, 35/2
Summicron, 1/125 f4/5.6
Kodachrome 25
Professional

So-called 'effects' filters are heavily promoted these days. Very occasionally they may prove useful but too often they are used excessively and unnecessarily, substituting gimmickry for creativity. The only one that I have found any real use for is a grey graduated, which allows pale skies to be darkened without destroying the naturalness of the scene.

Good-quality filters are essential if the quality of the Leica lenses is to be maintained. The range of filters supplied by Leica is limited and the alternatives listed below are of excellent quality:

Series filters	B & W
E48	B & W
E55	Minolta, B & W
E58	Pentax, B & W
E60	B & W
E67	Pentax, B & W
67EW	B & W
E72	Minolta, B & W
E77	Pentax, B & W

The B & W range (made in Germany) is particularly extensive.

MOTOR WINDER AND MOTOR DRIVE

The Leica motors are remarkably quiet, very smooth, quite fascinating to use and, like all of these devices, have a voracious appetite for film! Whilst they certainly can be very useful they are by no means as essential as the popular image of the top professional would have us believe. Contrary to popular belief, it is not common for a professional to fire off bursts of umpteen frames at a time with the motor drive on 'continuous'.

The real advantage of a motor is that the camera is always wound on and ready to shoot at the critical moment. It also avoids having to move the camera from the eye and is often a help when handling very long and heavy lenses. In close-up photography it avoids the danger of disturbing a critically focussed set-up – a real problem when winding on manually. More specialised applications may require remote operation of the Leica. The motor drive or winder can be connected to an electrical release via extension cables up to a maximum of 100m. The remote release also incorporates an intervalometer, allowing automatic firing of the shutter at intervals from ½sec to 10min.

Having said all the above, for most general photography you are at no great disadvantage without a motor. You can wind on manually as fast as the motor winder, you can operate more

AIRBORNE
A motor drive is a great help for sports photography. The main advantage is not so much for shooting sequences but for ensuring that the camera is always wound on and does not have to be removed from the eye.

Leica R3 MOT 180/3.4
Apo Telyt 1/1000 f5.6
TRI X

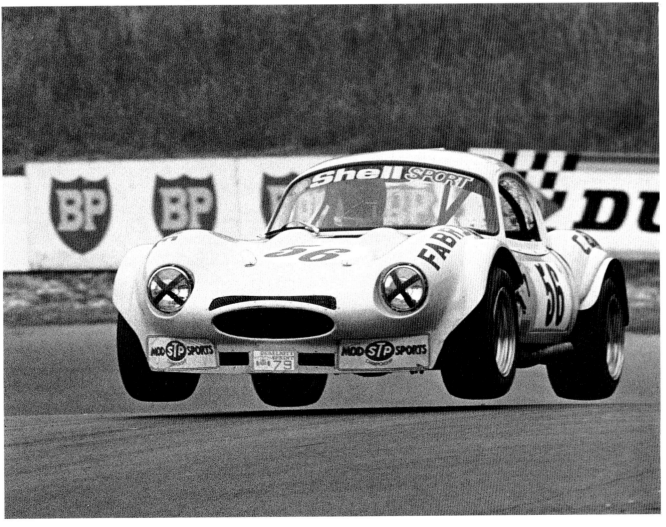

quietly and if you are carrying an outfit any distance you will be glad to save the weight.

When you do decide you need a motor, my recommendation would be to go for the motor drive rather than the winder. The difference between a speed of two frames per second and one of four frames per second may not seem much, but believe me when you need a motor you really need it! Once you have used a drive the winder seems frustratingly slow.

MOTOR DRIVE CUTAWAY

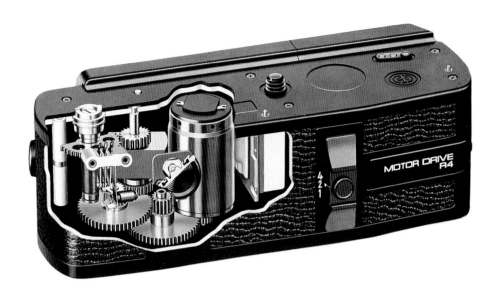

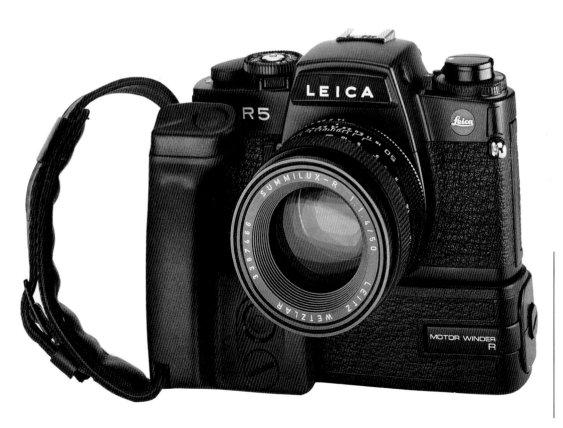

R5 WITH MOTOR WINDER
The motor winder and the motor drive fit the R4/4s/5/6/R-E cameras and are extremely smooth and quiet in operation. The drive can be set for single shot or continuous at either two or four frames per second. The handgrip is optional

TRIPODS

A good solid tripod is a photographer's best friend. One that is not firm or rigid is a waste of time. There are many good tripods on the market. Take your time, choose carefully and, if possible, borrow one to test it out in as many as possible of the situations in which you expect to use it. I have two tripods – a Kennet Benbo and a Leitz table tripod.

The Benbo, fitted with the large Leitz ball-and-socket head, although an extremely idiosyncratic device, is very rigid and incredibly versatile. It is especially favoured by wildlife and natural history photographers, who appreciate its sturdiness and its ability to allow photography at all sorts of peculiar angles down to ground level.

The table tripod travels everywhere with me in my camera bag. With the small ball-and-socket head it too is very firm and can be set up anywhere, supported on a wall or some other convenient place.

THE BENBO TRIPOD
The Benbo tripod is one of the most rigid, tough and versatile tripods available, although it is somewhat unusual in operation and takes time to master. Many wildlife photographers consider it indispensable for field photography

FLASHGUNS

The R5 and the R6 provide dedicated flash operation with TTL metering using guns compatible with the SCA 300 or SCA 500 systems. The appropriate adapter (SCA 351 or 551) must be used. Suitable units are available from Metz, Braun and others.

Apart from its use as the main illumination, flash is particularly useful to 'fill in' dark areas or heavy shadows in daylight or to support available light in industrial photography. Close-up photography of insects may also be helped by using flash and there is now an adapter to allow the use of a special Minolta unit designed for this purpose.

The flashgun I use is a Bauer. This is a hotshoe-mounted unit, yet is quite powerful – GN 38 (metres). As well as TTL it has an auto exposure setting with a full range of stops from f2.8 to f16. This is particularly useful for fill-in operation or when used with an R3 or R4.

SCA DEDICATED FLASHGUN
There is a good range of SCA compatible flashguns available for the dedicated systems on the latest Leica Reflexes. This unit is the Bauer Ultrablitz 38 Logic which, in addition to TTL dedicated operation with R5, R6 and R-E, has a range of six stops auto with normal synchronisation

FOUNDRY
The interior of the foundry was extremely dark. In order to record some detail in the foundryman without burning out the glow from the molten metal I used just a touch of flash. A full flash exposure would have destroyed the atmosphere.

Leicaflex SL2 35/2
Summicron 1/100 f5.6
Kodachrome 200
Professional

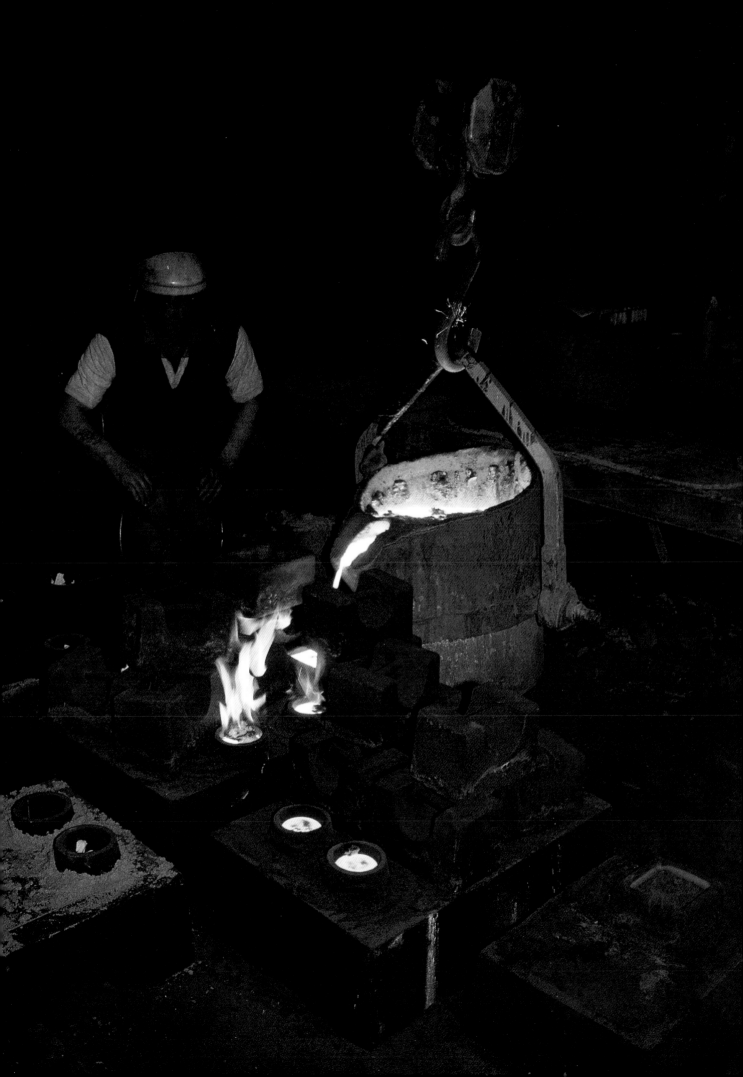

CASES
Leica offers a range of custom-fitted cases for outfits of varying sizes. There are also some excellent independent offerings from Billingham, Tenba, Domke and others

OUTFIT CASES

Every photographer I know has a different opinion on outfit cases, and most of them have a collection of different cases acquired over the years to prove that the opinion changes regularly!

For what it is worth, the case that seems to have stood the test of time and has gone almost everywhere with me for over five years is a medium-large Billingham. It is made by an English company that has been supplying quality bags to the hunting and fishing fraternity for nearly a hundred years. My bag is the second largest in the range and its weight when full is the limit that I can carry for a moderate distance. The maximum load is three camera bodies plus 21, 28 PC, 35/2, 60/2.8, 90/2 and the 180/3.4 lenses with 2× extender. The bag has adequate extra zip pockets and pouches for travel documents, notebooks, filters and eight rolls of film, which is generally ample for a day's shooting.

One other case that I use regularly when I want to travel light, or less conspicuously, is the compact version of the Leica small combination bag. According to the particular need, this will contain one body plus 21/4, 35/2 and 90/2, or one body plus 28/2.8, 50/2 and 70–210 zoom.

A very useful accessory for use with any outfit is the coupling ring (14836) that allows two lenses to be stored back to back, clearly saving valuable space.

EXPOSURE

Correct exposure is one of the essentials for quality results from the 35mm format. The Leica Reflex cameras have always been well engineered in this respect and the thinking photograper with an understanding of the basic principles and practice has an ideal tool.

From the 1968 Leicaflex SL onwards, all Leica Reflex cameras have featured very accurate TTL exposure metering with spot (central area) metering. The R3/4/5/6 also feature an optional averaging metering system, which is weighted in favour of the central and bottom areas of the frame. Spot metering offers the experienced photographer exceptionally precise control of exposure, even under the most difficult lighting conditions. Averaging metering provides accurate exposure in the majority of normal situations and is ideal for subjects where the photographer has to work quickly, or is grab shooting!

SENSITIVITY

Good sensitivity is obviously an advantage for a metering system. Not only can readings be made at lower light levels but accuracy over the whole range is likely to be improved. The table below lists the relative performance of the different Leica models.

METER SENSITIVITY

CAMERA	NON-TTL		TTL AVERAGE		TTL SPOT/SELECTIVE	
	cd/m2	EV	cd/m2	EV	cd/m2	EV
LEICAFLEX	2	+4				
SL					1.0	+3
SL2					0.125	0
R3			0.25	+1	0.25	+1
R4			0.25	+1	1.0	+3
R4s			0.25	+1	1.0	+3
R5			0.25	+1	1.0	+3
R6			0.063	−1	0.25	+1
R-E			0.25	+1	1.0	+3

NB Using ISO 100 film with an f1.4 lens, the exposure values (EV) represent light levels requiring the following exposures:

$$
\begin{array}{ll}
-1 \text{ EV} & 4\text{sec at f1.4} \\
0 \text{ EV} & 2\text{sec at f1.4} \\
+1 \text{ EV} & 1\text{sec at f1.4} \\
+3 \text{ EV} & \tfrac{1}{4}\text{sec at f1.4}
\end{array}
$$

PRINCIPLES

All exposure metering systems are calculated on the assumption that the reflectance of the subject is at 18 per cent. This is because, generally speaking, the light and dark zones of the picture area will average out at this 18 per cent and correct exposure

will be achieved. This applies whether a camera is being operated manually or whether it is in an automatic mode, as is possible with R3, R4 or R5 models.

The trick is to recognise when the subject area being read by the meter does not conform to the 18 per cent rule. Typical examples are when shooting into the light, or when the main subject is relatively small within overall dark surroundings – a spotlit performer on a darkened stage, for example – or when the subject overall is very light, as in a snow scene. The importance of knowing the area of subject being read by the meter will be apparent. The diagrams show this for the averaging and spot (central area) metering of the Leica R4/5/6/R-E series cameras.

PRACTICE

Spot metering allows the photographer to select an area of average tone and to meter off this. This can be done either manually or, in the case of the R3/R4/R5, in automatic aperture-priority spot mode by using the facility to lock a reading with slight extra pressure on the shutter release button. This is my preferred

TREES AND SNOW
Correct exposure for snow scenes is tricky. A casual approach will result in the meter being misled by the large areas of white, consequently causing underexposure. The easiest way to get it right is to spot meter a medium tone (eg a shadowed area of snow). Alternatively give one to one and a half stops more exposure than a general reading indicates

Leica R4, 35/2
Summicron 1/250 f5.6
Kodachrome 25

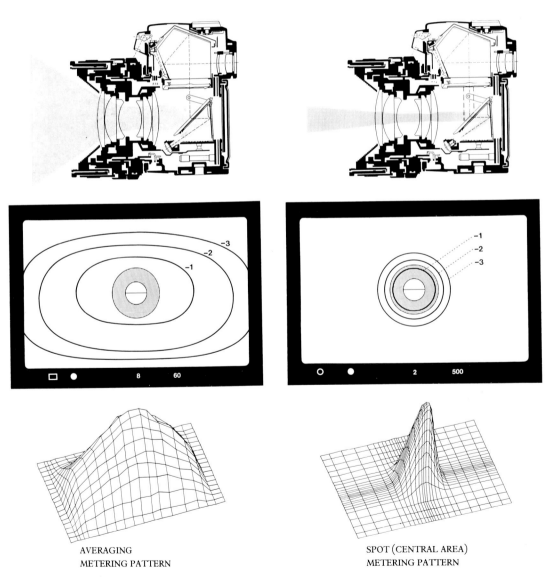

AVERAGING
METERING PATTERN

SPOT (CENTRAL AREA)
METERING PATTERN

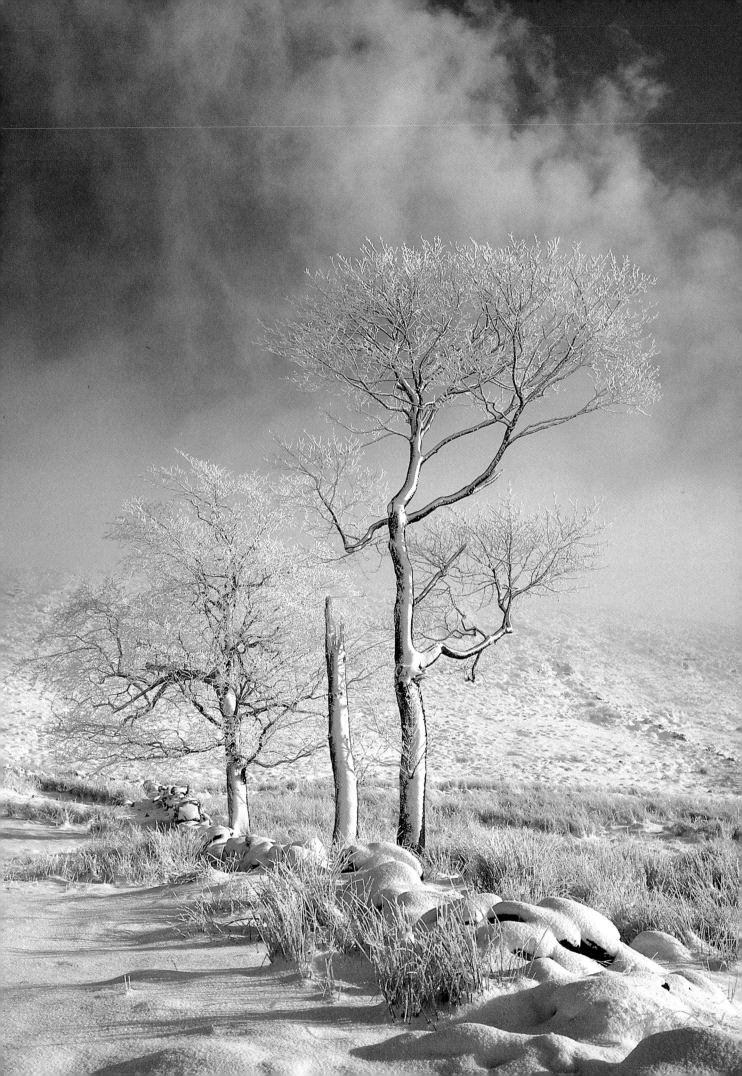

method as the camera I use most is the R5.

In the majority of cases it is easier to 'bracket' by metering a different tone rather than using the exposure compensation feature. There is always the danger that this latter is not returned to zero, with the consequent potential for disaster. Only when working from a tripod – eg for copying, close-up etc – is compensation more convenient.

BRACKETING

Difficult subjects often require some compromise on exposure. It is not always easy to determine the best compromise and bracketing is a normal practice for experienced photographers. It involves taking extra frames with the exposure usually adjusted plus or minus half a stop, although even plus or minus a full stop may be taken as well, in particularly problematic situations.

Colour transparency films require especially accurate exposure. Not only is the film itself more critical, with a half-stop variation readily apparent, but of course it becomes the finished product. There is no opportunity to compensate for slight errors, as there is at the printing stage of the negative–positive process. I mostly shoot with one of the slower-speed transparency films, which tend to be even more critical. For this reason I bracket plus/minus a half-stop on any really important subjects and, in some cases where results are perhaps less predictable, make additional exposures at plus/minus one full stop.

TOMBSTONE COURT-HOUSE, ARIZONA
It is an inescapable law of optics that all lenses vignette (ie give less light at the corners of the image than in the centre). The wider the angle the greater the natural vignetting.

Most times this is unimportant but with ultra-wide-angle lenses it is worth giving a little extra exposure (add a half stop) if there is important detail near the edges of the frame. Using the 21mm, as here, I usually lock a spot reading on a slightly darker tone than usual in order to achieve this.

Leica R4, 21/4 Super Angulon, 1/125 f5.6 Kodachrome 25

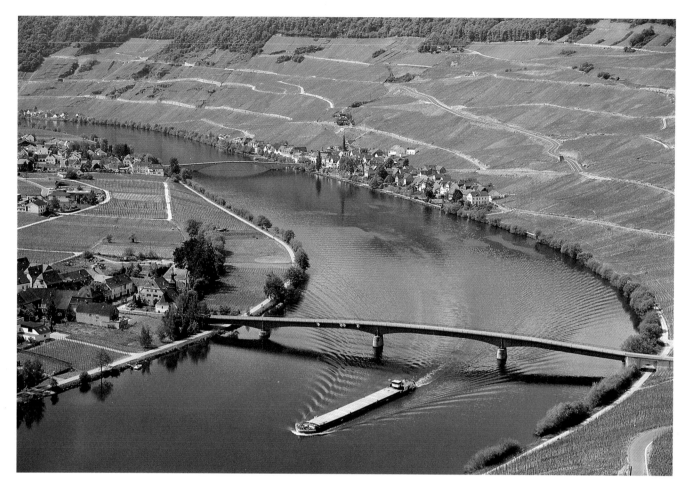

THE MOSEL NEAR
PIESPORT
Distant scenes taken
with a lens of long
focal length can often
benefit from a slight
reduction in the
indicated exposure,
especially with
transparency film. This
technique will improve
contrast and give more
saturated colours.

Leica R5, 180/3.4
Apo Telyt, 1/500 f5.6
Kodachrome 64
Professional

SPECIAL SITUATIONS

We have already mentioned the situation where the main subject requiring to be exposed accurately is only a very small part of an overall image area which is excessively light or dark in tone. This difficulty can be overcome by appropriate use of spot metering. Where the subject itself is very light or very dark – a snow scene or a dark-coloured car, for example – some adjustment will be required to overcome the metering system's assumption that it is reading an 18 per cent grey tone. In the case of the snow, more exposure than the meter indicates will be required to ensure that it records white. In the case of the car, less exposure will be required. This can be achieved either by using the exposure compensation facility (plus one stop approximately for the snow scene and minus one stop approximately for the car), or by reading a more appropriate tone with the spot.

There are other, less obvious situations where judicious modification of the indicated exposure is worthwhile. With ultra-wide-angle lenses a quarter to a half-stop extra exposure is needed, especially if there is important detail near the edges of the picture. This is to compensate for the natural vignetting of all lens systems, which becomes more apparent with wide-angles and wide apertures. With the 21mm, which I use a lot, I either spot meter a slightly darker tone or in some cases switch from spot to averaging to ensure that the darker areas influence the reading sufficiently.

HONG KONG FLOATING
RESTAURANTS
Night shots are really
best taken at dusk as
this allows some detail
to be retained in the
shadow areas without
burning out the
highlights.
Alternatively, plenty of
reflections from a wet
street or a harbour, as
here, will be helpful. In
a situation such as this
the bright lights will
tend to cause some
underexposure and
plus half to plus one
stop compensation is
needed. Always bracket
your exposures with
difficult subjects
anyway. Film is cheap!

Leica R4, 50/2
Summicron, approx 2sec
f2.8
Kodachrome 64

Conversely, some reduction of exposure (about half a stop) can
be tolerated with distant subjects taken with longer (over
135mm) lenses. This is because generally you are reading darker
tones than average, and also because slight underexposure helps
to improve the contrast and colour saturation that has been
reduced by intervening haze.

Night and other scenes requiring very long exposures bring in
the problem of reciprocity failure. The normal sensitivity of the
film to light is reduced at lower light levels, and a situation that
the meter indicates as requiring an exposure of, say, 2 seconds
may in practice need to be doubled. This loss of sensitivity varies
from film to film, and with colour films can also cause noticeable
shifts in colour balance. For critical applications, the film manu-
facturer will give detailed information on the exposure compen-
sation and filtration required. My own rather rough-and-ready
practice, however, is to bracket exposures, giving increases of
half stop and one stop for scenes that require exposures over one
second and up to eight seconds. Indicated exposures longer than
eight seconds are given yet another stop compensation. This
seems to work for most subjects.

SUNSET, STOCKPORT
Few photographers can
resist a good sunset.
The important thing is
to try to get some
interesting subject
matter to set off the
attractive sky.
Exposure is relatively
simple. You do not
want detail in the
foreground – a
silhouette effect is
usually best – and a
spot reading from the
sky but avoiding the
sun will give a
satisfactory result.

Leicaflex SL, 50/2
Summicron, 1/60 f4
Kodachrome 25

CLOSE-UP PHOTOGRAPHY

Leica has provided a choice of excellent options to facilitate close-up photography with its Reflex cameras. These range from the Elpro supplementary lenses that screw into the front of the lens like a filter, to the highly specialised Photar lenses used on the bellows unit for high magnification requirements. Because of the various possibilities, with close-up photography it is normal to refer to image ratios which indicate the reduction from actual size to the image on the film. Thus half lifesize becomes 1:2, quarter lifesize 1:4, et seq. Lifesize on film is 1:1 and twice lifesize 2:1.

ELPRO

These lens attachments provide a simple, effective way to achieve closer focussing with normal lenses. They are very light and take up little space in the outfit case.

Table B (p74) shows the possibilities with various lenses, but the most useful combinations are the Elpro 1 with the 50mm Summicron and the Elpro 3 with the 90mm lenses. Elpros 1, 2, 3 and 4 are two-element achromats that maintain good optical correction in the close focussing range. Although in absolute technical terms a normal lens plus Elpro may not be as good as a specially computed macro lens, the deficiencies are mainly to do with flatness of field and edge definition. Only rarely are these factors critical. With the majority of pictorial work, the results will be indistinguishable.

Because it must not be used with extension devices such as the Macro Adapter, the bellows or the ring combination, there is a special Elpro for the 100/2.8 Apo Macro Elmarit to extend its

WATER DROPLETS
There are many fascinating pictures to be made in the ultra-close-up range. I saw these droplets glistening on a plant after a rain shower. They were very tiny and I needed a lifesize image on the film to capture the effect. The lens was stopped down to f11 but even so the depth of field was very limited, throwing the background nicely out of focus.

Leica R4, 100/2.8 Apo Macro with Elpro, 1/2sec f11
Kodachrome 25
Professional

ELPRO LENS
This special Elpro lens allows the 100/2.8 Apo Macro Elmarit to focus to slightly larger than life-size

HIBISCUS, CRETE
This flower caught my eye in our hotel gardens. Travelling light I had no specialist close-up equipment with me, but the Elpro 3 on a 90mm lens produced an excellent result.

Leica R4, 90/2 Summicron with Elpro 3, 1/125 f5.6
Kodachrome 25

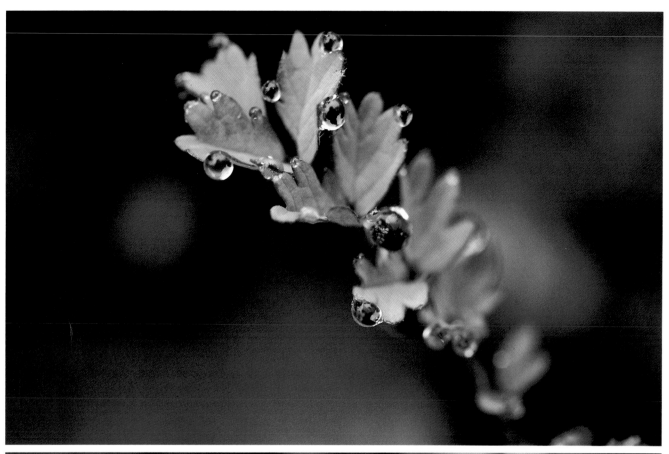

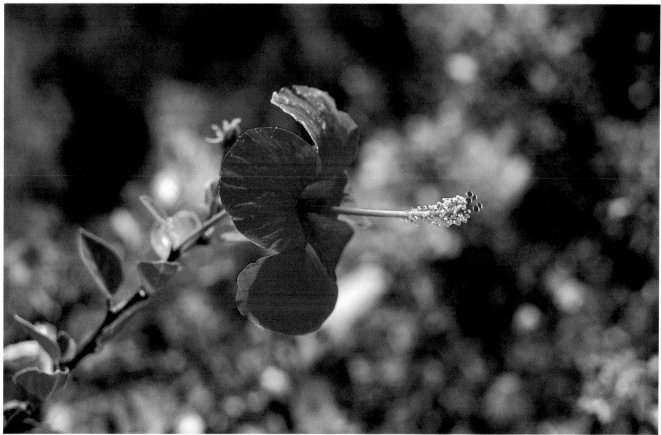

focussing from the normal closest focussing (giving 1:2 image ratio). This is a three-element attachment specially computed to maintain the outstanding optical quality of this lens through to an image slightly larger than lifesize (1.1:1).

MACRO LENSES

Strictly, macro photography begins when images larger than lifesize are obtained on the film. However, convention now applies the term to equipment allowing image ratios greater than that achievable with normal lenses – about 1:6. Leica has three special macro lenses providing these higher image ratios. These lenses are specially computed to give optimum performance in the near range (1:3–1:10) rather than infinity.

MAXIMUM IMAGE RATIO

	NORMAL FOCUSSING	WITH MACRO ADAPTER/ELPRO
100/2.8 Apo Macro Elmarit	1:2	1.1:1
60/2.8 Macro Elmarit	1:2	1:1
100/4 Macro Elmar	1:3	1:1.5

In terms of image quality the 100/2.8 Apo is undoubtedly the best of the three lenses, with the Apo correction actually maintained throughout the entire focussing range. The 60/2.8 delivers slightly higher contrast than the 100/4. The latter, however, provides particularly even quality across the frame and throughout the range of f stops. The extra working distance provided by the 100mm lenses can be a great convenience when using flash or other lighting and is particularly valuable when photographing butterflies or other insects, as the likelihood of disturbing them is reduced.

Mention should perhaps be made of the 70–210 zoom, which at the 210 setting and the nearest focussing distance provides a 1:4 image ratio. The quality is quite reasonable but obviously will not compare with the specially computed macro lenses.

MACRO LENS
The 60/2.8 Macro Elmarit is a symmetrical optical design providing excellent quality throughout the entire focussing range. Optimum results are in the range 1:6 to 1:10

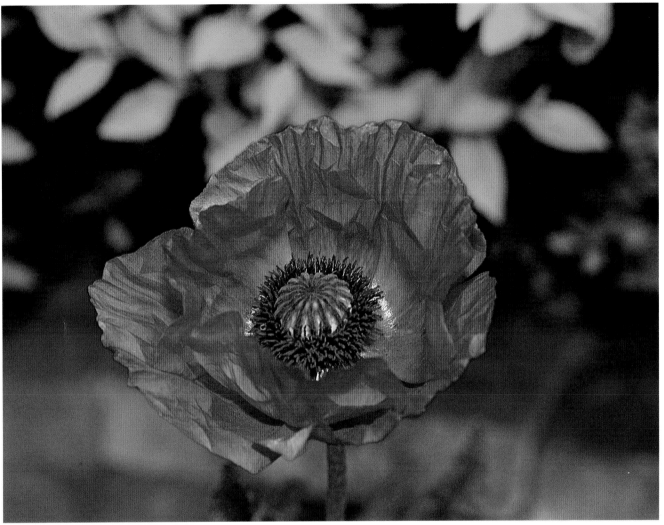

POPPY BUD AND FLOWER
My wife was delighted with the colour that the California poppies which she had planted gave to the garden. We found a bud that was just about to burst open and a good example of a freshly opened flower. Recording them was straightforward when using the Apo Macro Elmarit and with the camera on the Benbo tripod.

Leica R6, 100/2.8 Apo Macro, 1/60 f11
Fuji Velvia

DRAGONFLY

I was on a short business visit to Zambia and travelled very light with an R4 body, 28/2.8, 50/2 and 70/210 zoom lenses. The zoom does have quite a reasonable close focus capability (1:4) but this is at the 210mm setting. With no tripod I had to use 1/500sec to avoid camera shake and could only stop down to f5.6. The result, however, is adequate and demonstrates the versatility of this lens.

Leica R4, 70/210 Vario Elmar, 1/500 f5.6 Kodachrome 64 Professional

MACRO ADAPTER AND RING COMBINATION

Both these devices are inserted between the lens and the camera body, thereby increasing the extension and extending the focussing range of any lens (see Table C, p75). The Macro Adapter is much simpler and more convenient but can only be used with the 'R' camera models (not Leicaflex models). Not recommended for use with the zoom lenses or the Apo Macro Elmarit.

FOCUSSING BELLOWS

For serious close-up photography, the continuously variable extension provided by the bellows unit offers many advantages. A whole range of different lenses can be used, including the special Photars which give very high magnifications, and a version of the 100/4 lens which gives continuous focussing from infinity to 1:1.

Although it can be used for hand-held photography, the unit is at its best on a tripod with relatively static subjects. With the aid of the graduated scale, precise image ratios can be set if required. The facility to rack the whole unit backwards and forwards when framing and focussing a subject is a very great convenience. Anybody who has tried inching a tripod around when working at high image ratios will understand the value of this feature.

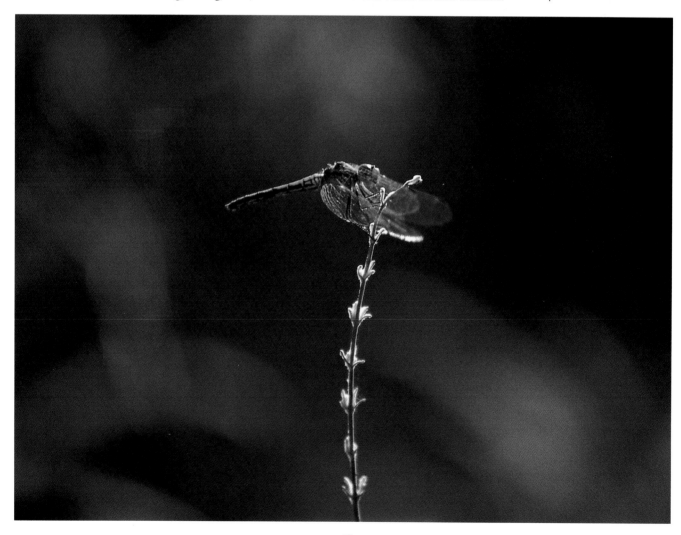

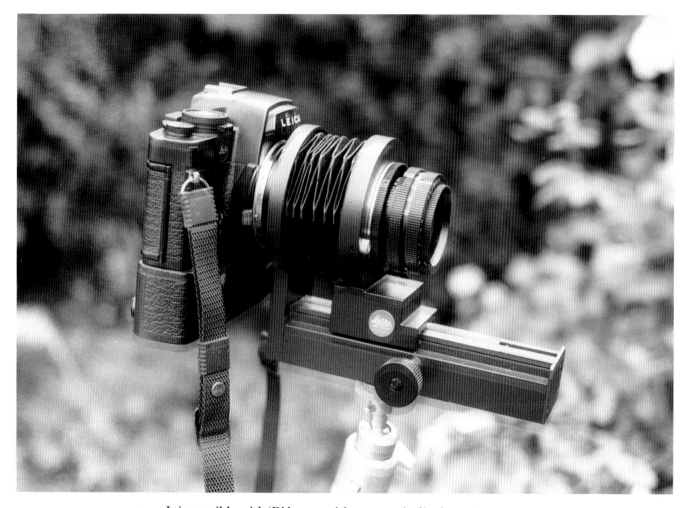

It is possible with 'R' lenses with automatic diaphragm to use a twin cable release that allows full aperture focussing with semi-automatic stop-down. This is not such an advantage when working on a tripod with static subjects and is not possible with other lenses, such as the Photars or the author's favourite – a 65/3.5 Elmar, ex a Visoflex outfit, that focusses from infinity to 1.5:1.

ACCESSORIES

Focussing is critical for close-ups. Depth of field is extremely limited even at small stops (see Table E, p77) and is related to image ratio irrespective of lens focal length. Two small accessories that are therefore almost essential are a plain ground glass screen (preferably with the grid divisions which can be used to indicate image ratios) and the right angle finder, which not only allows convenient viewing of low-level subjects but also has a built-in 2× magnifier to facilitate critical focussing. This finder has its own dioptre adjustment, allowing good clear vision of the image. Remember, however, that slight adjustment is required when switching to and from the 2× magnification.

Small stops and loss of light due to lens extension lead to shutter speeds that are often impracticable for hand-held work, even at moderate image ratios. Also anything closer than 1:2 is very difficult to focus without some support, so that an absolute

BELLOWS UNIT
The 'R' bellows unit is an extremely well-designed and engineered accessory. It is particularly convenient for ultra-close-up photography and can be used with a whole range of lenses, including some 'M' Visoflex lens heads and the special Photars for magnification up to 16×

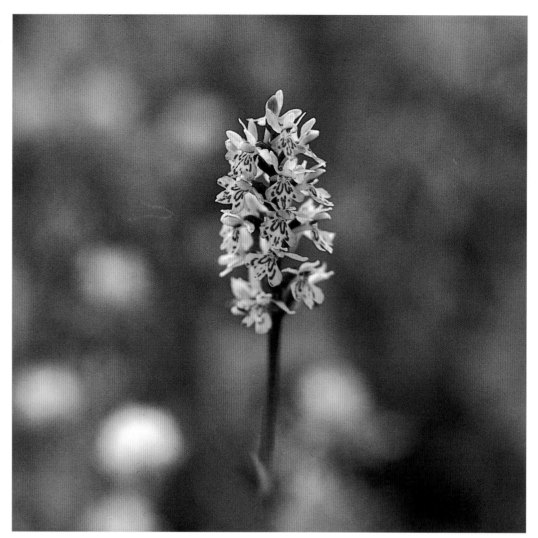

MARSH ORCHID
For serious close-up photography the bellows unit has many advantages. A wide selection of lenses can be fitted – some, such as the Photars, giving magnifications up to 16×. The lower rack allows precise positioning of the camera without having to move the tripod, which is a convenience that has to be experienced to be appreciated. An adapter allows the use of 'M' Visoflex lenses, one of my favourites (shown here) being the 65/3.5 Elmar which allows focussing from infinity to 1.5× lifesize.

Orchid: Leica R4, 65/3.5 Elmar on bellows 'R', 1/4sec f11 Kodachrome 25

Camera etc: Leicaflex SL2, 50/2 Summicron, 1/125 f5.6 Kodachrome 64

essential is a good solid tripod. The Benbo, already referred to earlier, is highly recommended because it can be set up to allow photography at almost any level and with the most difficult ground conditions. In the field, in good light, some photographers use a monopod but all the serious nature photographers that I know take the trouble to carry a tripod.

The motor drive or winder is useful when working very close on a tripod. It is very easy to disturb a critically focussed and framed subject when winding on manually. Motorised operation avoids this. For the same reason, and to avoid camera shake, it is best to use a cable release (or the remote release for the motor) rather than firing the shutter manually. Another useful trick to avoid camera shake when the subject is static is to use the delayed action. Any vibration induced by releasing the shutter will have settled by the time that it fires.

Although I prefer to use natural light whenever possible, flash is often necessary for insect photography, ultra-close-up work or copying transparencies. TTL light metering from the SL onwards released photographers from tedious calculation of exposure adjustment to compensate for lens extension in the close-up range. Now TTL flash metering on the R5, R6 and R-E

SPEEDWELL
This flower is very tiny and was photographed with the 65mm lens on the bellows at maximum magnification: 1.5 × lifesize. Although the lens was stopped down to f16 the depth of field is extremely limited – 1mm (1/25in) – and exposure very extended.

Leica R4, 65/3.5 Elmar on bellows 'R', 1sec f16 Kodachrome 25

MACRO FLASH
Quite often close-up photography requires illumination by electronic flash. Leica has adapted the excellent Minolta Macro Flash for use on the R5, R6 and R-E, retaining full TTL dedication

has similarly simplified the use of flash. It is just possible to use satisfactorily a TTL dedicated flashgun on the camera hot shoe if there is sufficient working distance between the lens and the subject, but obviously an off-camera flash with appropriate adapter to maintain the TTL metering is even better. Leica has now made available suitable adapters for a Minolta Macro Flash unit, which is of course ideal.

LIGHTING

Outdoors, the best natural light for close-up photography is diffused sunlight. This occurs on days when there is a very thin layer of high cloud, or on days with a lot of haze. Almost as good are days with plenty of nice white clouds around. These reflect light into the shadow areas, or you can wait until the sun is diffused by the edge of a cloud.

Indoors I still prefer natural light. North light from a large window, in conjunction with white card reflectors, is excellent for moderate close-ups. Flash bounced off a wall or ceiling to supplement the natural light, or to push extra light into the shadow areas, is sometimes useful. In this situation the TTL flash metering of the R6 is best, as (unlike the R5) the system leaves the shutter speed set for the natural lighting and does not switch it automatically to the X synchronisation speed of 1/100 sec.

GARDEN SPIDER
Pictures of insects can be taken without flash but patience is needed to keep the subject in focus whilst waiting for movement of the subject itself, or any caused by wind, to cease. To allow a reasonable shutter speed I could only stop down here to f8. Lighting was ideal – a slightly hazy sun.

Leica R4, 100/4 Macro on bellows 'R', 1/30 f8 Kodachrome 64

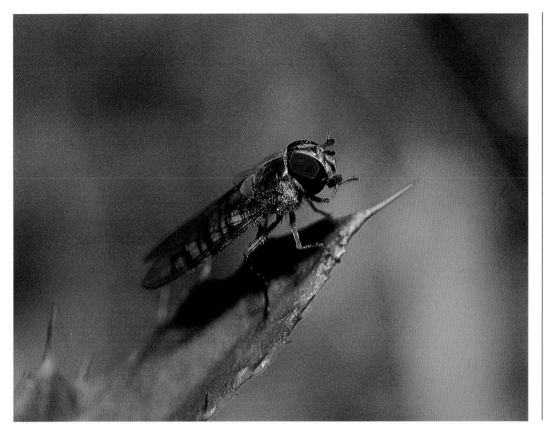

HOVERFLY
For close-up subjects such as insects, extended exposures are not possible so that electronic flash is often needed to give sufficient light and to freeze any movement. The TTL flash metering of the R5, R6 and R-E is a great advantage for close-ups.

Leica R5, 100/2.8 Apo Macro with Elpro, electronic flash, 1/100 f11 Kodachrome 25 Professional

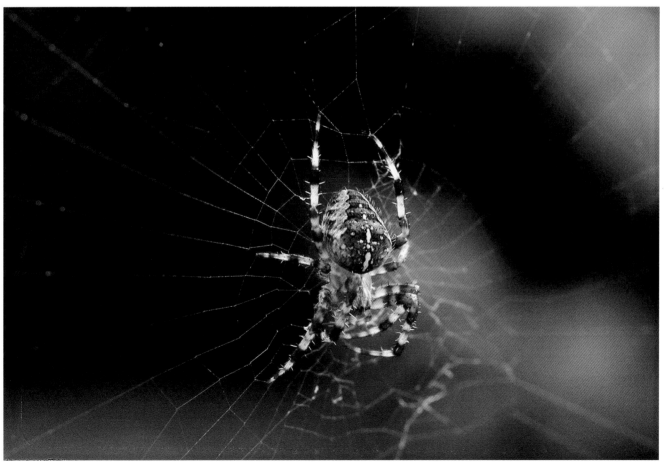

TABLE B

ELPRO CLOSE-FOCUS ATTACHMENTS FOR LEICA R LENSES						
Lens	ELPRO Code No.	Distance scale at	Distance in cm Object to film	Object to front lens	Object field in mm	Reproduction scale
SUMMICRON-R f/2/50 mm from No. 2777651 (E 55)	1 16541	∞ 0.5	50 31	41 21	184x276 91x137	1:7.7 1:3.8
	2 16542	∞ 0.5	30 24	21 14	94x141 62x 93	1:3.9 1:2.6
SUMMICRON-R f/2/90 mm from No. 2770951 (E 55)	3 16543	∞ 0.7	74 44	61 30	161x241 72x108	1:6.7 1:3.0
ELMARIT-R f/2.8/90 mm from No. 2809001 (E 55)	3 16543	∞ 0.7	74 44	61 30	161x241 72x108	1:6.7 1:3.0
MACRO-ELMAR-R f/4/100 mm (E 55)	3 16543	∞ 0.6	75.5 41.6	61 24	145x218 48x 72	1:6 1:2
	+ Macro-Adapter-R 14256	∞ 0.6	42 37.4	24 17	49x 73 29x 44	1:2 1:1.2
	4 16544	∞ 0.6	150.5 48.6	136 31	323x484 61x 92	1:13 1:2.5
	+ Macro-Adapter-R 14256	∞ 0.6	48.8 40.4	31 20	63x 94 34x 51	1:2.6 1:1.4
APO-MACRO-ELMARIT-R f/2.8/100 mm	16545	∞ 1.2	35.4 30.5	16 10	49x 73 22x 33	1:2 1.1:1
ELMARIT-R f/2.8/135 mm from No. 2772619 (E 55)	3 16543	∞ 1.5	76 58	61 42	107x160 66x 99	1:4.5 1:2.8
	4 16544	∞ 1.5	150 84	135 68	237x355 106x159	1:9.9 1:4.4

All values rounded off.

TABLE C

MACRO-ADAPTER-R for LEICA R models (preferably with aperture priority and manual mode)				
Lens	Distance scale at (m or reproduction scale)	Distance object to front lens in cm	Reproduction scale	Object field in mm
SUMMICRON-R f/2/50 mm	∞	11.6	1:1.75	42x 63
	0.5	9.9	1:1.42	34x 51
MACRO-ELMARIT-R f/2.8/60 mm	∞	16	1:2	48x 72
	1:2	9.7	1:1	24x 36
SUMMICRON-R f/2/90 mm	∞	32	1:3	72x108
ELMARIT-R f/2.8/90 mm	0.7	23	1:2	48x 72
MACRO-ELMAR-R f/4/100 mm	∞	42	1:3.3	80x120
	0.6	25	1:1.6	39x 59
ELMARIT-R f/2.8/135 mm	∞	75	1:4.5	108x162
	1.5	55	1:3	72x108
ELMARIT-R f/2.8/180 mm	∞	124	1:6	144x216
	1.8	78.4	1:3.4	82x123
APO-TELYT-R f/3.4/180 mm	∞	133	1:6	144x216
	2.5	95.6	1:3.9	95x142
TELYT-R f/4/250 mm	∞	256	1:8.4	202x303
	1.7	99.1	1:2.9	70x105
TELYT-R f/4.8/350 mm	∞	477	1:11.6	278x417
	3.0	178	1: 4.1	97x146

RING COMBINATION FOR THE CLOSE-FOCUS RANGE for LEICA R models (preferably with aperture priority and manual mode) and LEICAFLEX SL/SL2 models							
Lens	Distance scale at	Ring combination					
		2-part (height 25 mm) 14 158			3-part (height 50 mm) 14 159		
		Distance object to front lens cm	Reproduction scale	Object field mm	Distance object to front lens cm	Reproduction scale	Object field mm
SUMMICRON-R f/2/50 mm	∞	13.5	1:2.1	50x 75	8.1	1:1.04	25x 37
	0.5	11.2	1:1.6	38x 58	7.5	1.09:1	22x 33
SUMMICRON-R f/2/90 mm	∞	37.6	1:3.6	86x130	21.4	1:1.8	43x 65
ELMARIT-R f/2.8/90 mm	0.7	25.2	1:2.2	53x 79	17.6	1:1.4	34x 50
ELMARIT-R f/2.8/135 mm	∞	87.2	1:5.4	130x195	50.7	1:2.7	65x 97
	1.5	59.7	1:3.4	81x121	42.3	1:2.1	50x 75
ELMARIT-R f/2.8/180 mm	∞	146	1:7.2	172x258	81.2	1:3.6	86x129
	1.8	84.9	1:3.8	91x137	61.3	1:2.5	60x 90
APO-TELYT-R f/3.4/180 mm	∞	154	1:7.2	172x258	89.4	1:3.6	86x129
	2.5	104	1:4.4	106x159	74.0	1:2.7	66x 99
TELYT-R f/4/250 mm	∞	299	1:10.1	242x363	172	1:5.0	121x181
	1.7	104	1:3.2	76x114	85.8	1:2.3	55x 82
TELYT-R f/4.8/350 mm	∞	558	1:13.9	334x501	316	1:7.0	167x250
	3.0	187	1:4.4	105x157	153	1:3.2	76x114

All values rounded off.

TABLE D

POSSIBILITIES OF COMBINATION WITH LEICA R LENSES ON THE FOCUSSING BELLOWS-R			
Lens	Reproduction scale	Distance object to front lens cm	Object field mm
SUMMICRON-R f/2/50 mm	1:1.2 – 2.9:1	9.1 – 4.5	29.6x44.4 to 8.4x12.5
MACRO-ELMARIT-R f/2.8/60 mm	1:1.5 – 2.8:1	12.5 – 5.7	35x53 to 8.5x12.8
SUMMICRON-R f/2/90 mm ELMARIT-R f/2.8/90 mm	1:2.1 – 1.8:1	24.5 – 10.4	51.1x76.6 to 13.7x20.6
MACRO-ELMAR® f/4/100 mm	∞ – 1:1	∞ – 18.7	∞ to 24.0x36.0
MACRO-ELMAR-R f/4/100 mm with helical focussing mount	1:2.4 – 1.7:1	32.6 – 14.7	57.1x85.7 to 14.2x21.3
ELMARIT-R f/2.8/135 mm	1:3.2 – 1.2:1	57.7 – 25.9	77.2x115.8 to 20.6x30.9
ELMARIT-R f/2.8/180 mm	1:4.3 – 1:1.09	93.5 – 36.3	102.7x154.0 to 26.2x39.4
APO-TELYT-R f/3.4/180 mm	1:4.3 – 1:1.14	101.8 – 45.3	102.7x154.0 to 27.4x41.1
TELYT-R f/4/250 mm	1:6 – 1:1.1	195.9 – 62.2	144.0 – 216.0 to 27.4x41.1
TELYT-R f/4.8/350mm	1:8.3 – 1:1.6	362.0 – 107.0	199.0x298.0 to 38.0x57.0
M lenses on the Focussing Bellows-R 65 mm ELMAR-M f/3.5 (∞ – 1.5:1) Lens unit of the 90 mm ELMARIT-M f/2.8 (∞ – 1.1:1) Lens unit of the 135 mm TELE-ELMAR-M f/4 (∞ – 1:1.3)			

All values rounded off.

TABLE D *continued*

PHOTAR LENSES FOR THE FOCUSSING BELLOWS-R					
Lens	Code No.	short bellows extension		long bellows extension	
		reproduction scale	free working distance	reproduction scale	free working distance
PHOTAR 1:2.4/12.5mm	549025	7.5:1	8mm	15.5:1	7mm
PHOTAR 1:2/25mm	549026	3:1	22mm	7:1	17mm
PHOTAR 1:4/50mm	549027	1.2:1	88mm	3.2:1	59mm

All values rounded off. The free working distance is the distance between the object and the lens mount.

TABLE E

DEPTH-OF-FIELD RANGE AT REPRODUCTION SCALES FROM 1:20 TO 10:1 The round values are based on a circle of confusion of 1/30mm.							
Reproduction scale	Magnification	Extension factor with exit:entry pupil ratio 1:1	Depth of field in mm				
			f/4	f/5.6	f/8	f/11	f/16
1:20	0.05	1.1x	110	154	220	308	440
1:15	0.067	1.1x	65	90	130	180	260
1:10	0.1	1.2x	30	40	60	80	120
1:5	0.2	1.4x	8	10	15	20	30
1:4	0.25	1.6x	5.5	7.5	11	15	22
1:3	0.33	1.8x	3	4.5	6	9	12
1:2	0.5	2.3x	1.5	2	3	4	6
1:1.5	0.67	2.8x	1	1.4	2	2.7	4
1:1	1	4x	0.5	0.7	1	1.4	2
1.5:1	1.5	6.3x	0.3	0.4	0.6	0.8	1
2:1	2	9x	0.2	0.3	0.4	0.6	0.8
3:1	3	16x	0.1	0.2	0.25	0.35	0.5
4:1	4	25x	0.08	0.12	0.16	0.23	0.32
5:1	5	36x	0.06	0.09	0.13	0.18	0.26
6:1	6	49x	0.05	0.07	0.10	0.14	0.20
7:1	7	64x	0.04	0.06	0.09	0.12	0.17
8:1	8	81x	0.04	0.05	0.08	0.10	0.15
9:1	9	100x	0.03	0.05	0.07	0.09	0.13
10:1	10	121x	0.03	0.04	0.06	0.08	0.12

PHOTOGRAPHING PEOPLE

People are a source of endless fascination to other people and recording them is a major photographic interest. The Leica is an ideal camera for this purpose. It is light and portable and, with its variety of lenses, can be used to make pictures of people at work, at play, indoors, outdoors, informal or formal. It is instantly ready for those unrepeatable family moments and the quality is such that formal portraits can be made to the highest standards. It is robust enough to accompany travellers and explorers and to

PETER
Nice soft lighting from a sun veiled by the edge of a cloud was ideal for this outdoor shot. The longer focal length lens gave good perspective rendering.

Leicaflex SL, 135/2.8 Elmarit, 1/250 f4 Kodachrome 25

THAI DANCER
The traditional costume and make-up of this elegant lady provided an irresistible subject. The 90mm lens was the ideal focal length, giving natural perspective and allowing the background to be kept nicely out of focus.

Leica R4, 90/2 Summicron, 1/250 f4 Kodachrome 25

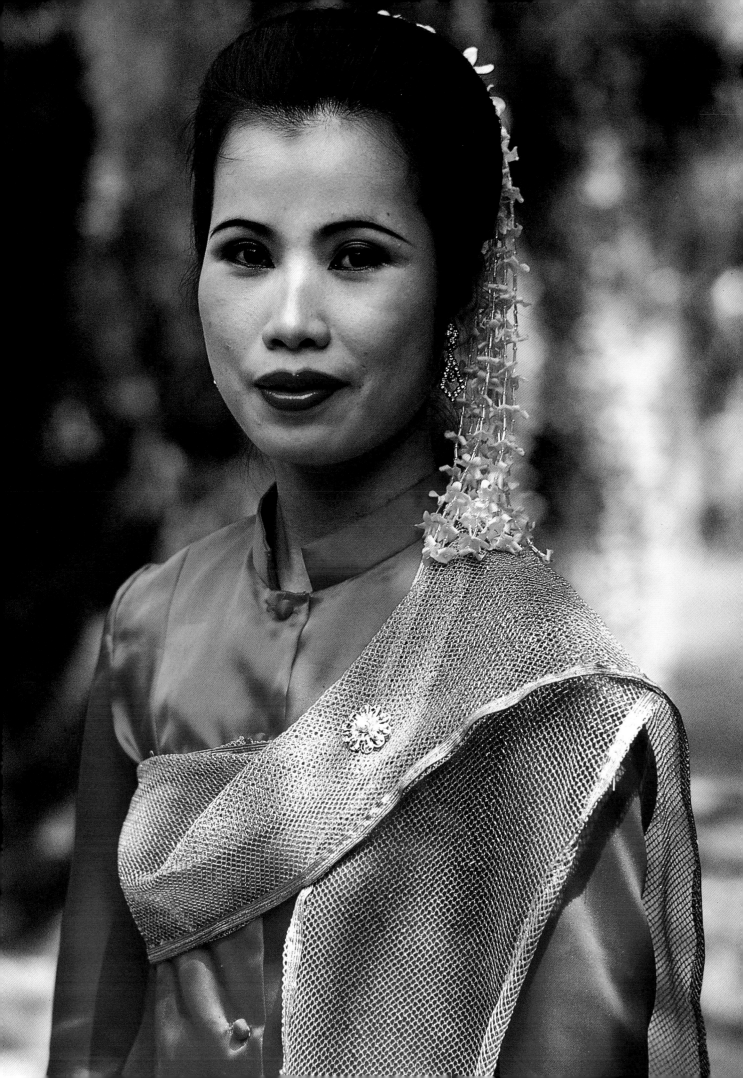

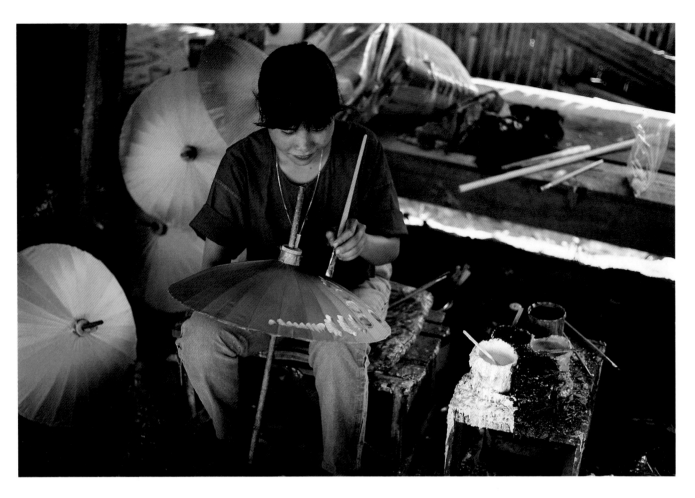

UMBRELLA PAINTER,
CHIANG MAI
Chiang Mai in the
north of Thailand is a
centre for many
traditional crafts. I
wanted to include the
girl's work to tell more
of a story and used the
50mm lens. Her face
was heavily shadowed
so I used fill-in flash to
ensure adequate
exposure.

Leica R3, 50/2
Summicron, 1/100 f4
Kodachrome 25

record people under the most arduous conditions of cold, heat and humidity.

FORMAL

Conventional, more formal portraits – head or head and shoulders – are best taken with a medium telephoto lens, the 90 or the 100. With these focal lengths the perspective is natural and by using a fairly wide aperture, f4 or wider, it is easily possible to ensure that the background is well out of focus and does not distract. The key point of interest is the eyes. These, together with the tip of the nose and the forehead, must be sharp but it does not matter so much – it can even be an advantage – if other elements such as shoulders, back of head etc are out of focus. Ideally the camera should be at the same level as the eyes. Looking down on a person or upwards from a low angle can be disturbing unless done intentionally.

ENVIRONMENTAL PORTRAITS

Environmental portraits, where the subject is shown in places or with elements that inform the viewer about the sitter's work or interests, can be very satisfying. In these cases a medium wide-angle – a 28 or a 35 – will be valuable. The 35mm Summicron R is particularly useful, as it can be used at its full aperture so that the background is out of focus enough to avoid distracting attention from the face but is sharp enough to be informative.

STRIDING EDGE,
HELVELLYN
Here even more of the
surroundings are
included. Now you
have to decide whether
you want a person with
landscape or a
landscape with figure.
This just about comes
into the first category.

Leica R4, 35/2
Summicron, 1/125 f5.6
Kodachrome 25

HILL TRIBE CHILDREN,
THAILAND
Groups are extremely
difficult to photograph.
Here I wanted to show
the children in their
village environment.
Patience, quick camera
work and much bribery
with sweets were the
order of the day.

Leica R4, 28/2.8 Elmarit,
1/125 f5.6
Kodachrome 25

80

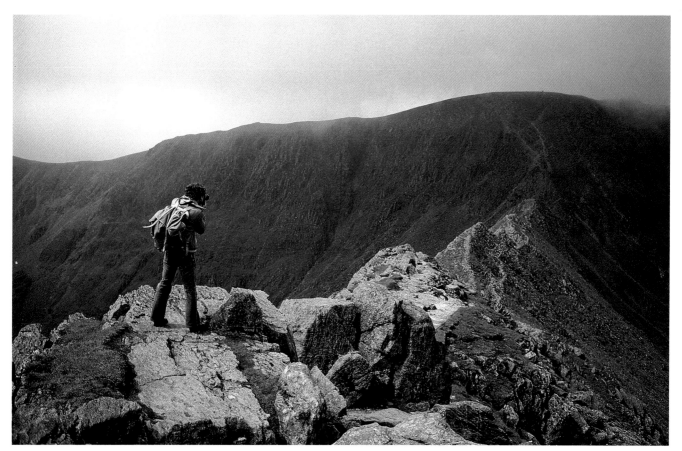

BUBBLE GIRL
Small children are best photographed playing. Good opportunities may occur naturally: my little girl was blowing bubbles when I noticed the superb rim lighting of her hair and the bubbles. By using a medium telephoto lens I was able to isolate her against a dark, out-of-focus background to enhance the effect. Be prepared to use lots of film: this was much the best of over a dozen shots.

90/2 Summicron, 1/250 f2.8
Kodachrome 64

GROUPS

Whether formal or informal, groups are the most difficult test. Difficulties mount according to the square of the number of people involved. Getting good results needs some luck and the acceptance that you must shoot a lot of frames, most of which will be spoilt by at least one person with their eyes closed or with a strange expression. Persistence is the only answer.

FAMILY

I think that it was a Kodak advertisement that said 'The pictures you will want to look at tomorrow need to be taken today.' Whatever your other photographic interests, professional or otherwise, never underestimate the importance of family photographs. Five, ten, twenty years hence, these will continue to be of absorbing interest. It will pay, therefore, to apply every bit as much time, skill and technique to these as to any other subject. Not only should you plan ahead a little in order to record important anniversaries, but you should always be ready at a moment's notice to capture those totally unpredictable moments of joy or humour. Fast lenses and a moderately fast film are

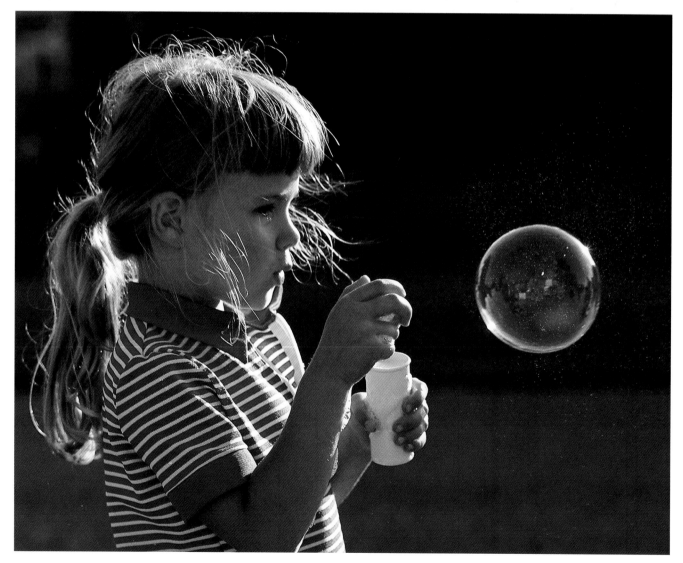

valuable so that you can work easily and unobtrusively with natural light. The 35mm and 90mm Summicrons are a good combination. Outdoors the slow, high-quality films can be used but this is one subject area where technical quality is secondary to the moment and the expression.

LIGHTING

In my opinion natural light is best for portraits. Even in a studio some of the finest portrait photographers prefer to use daylight (usually north light), controlling its direction and contrast by using reflectors and shades. Not only does natural light have a special quality but the sitter feels less overpowered by technical paraphernalia and is more quickly put at ease.

Outdoors, strong sunlight is best avoided as this leads to people screwing up their eyes, as well as excessive contrast. Veiled sunlight and even slightly dull days are best. If you do have to take pictures on sunny days, shoot with the sun behind or well to one side of your subject and use a reflector (a large piece of white card will do) to ensure good detail in the shadow areas.

Alternatively a small flashgun on the camera can be used to fill in the shadows. This latter technique is also very useful when

THOMAS
With children it is important to get down to their level with the camera. My grandson was much amused by my antics crawling through the grass.

Leica R5, 90/2 Summicron, 1/250 f2.8 Kodachrome 25 Professional

travelling in tropical countries, where the sun is directly over-head in the middle of the day and very heavy shadows result. Don't overdo the flash – it should not be obvious that it has been used.

BLACK AND WHITE PORTRAITS

Many famous portrait photographers still prefer to work with black and white film. Eliminating the factual realism of colour can facilitate concentration on character, often producing images of more lasting interest. This applies also to photojournalists. The handy Leica with its excellent fast lenses and an ISO 400 film is an ideal tool.

SARAH
There is still a great deal to be said for portraiture in black and white, as this delightful study shows.

Leicaflex I, 90/2.8 Elmarit

LANDSCAPES

Places, landscapes in the broadest sense, or scenics as some people call them, are almost certainly the most generally popular subject for photographers. Everybody likes to record the places that they have visited, a great deal of commercial work is concerned with location photography and, from an artistic point of view, good landscape photography is extremely satisfying.

The trouble is that with a modern, quality camera such as the Leica it is relatively easy to produce excellent records, but to capture atmosphere, mood, the real feeling of a place, is much more demanding – not so much of the equipment, but of the photographer's skill, experience and imagination. The great Impressionist painter Claude Monet once said, 'A landscape hardly exists at all as a landscape, because its appearance is constantly changing; it lives by virtue of its surroundings, the air and light, which vary continually.' It is this subtle moment when the place, the light and the atmosphere fleetingly combine to perfection that the true landscape photographer constantly seeks.

ZAMBESI SUNSET
Skies are a vital element in landscape photography. This simple composition was 'made' by the harmonious position of the clouds and by waiting until the precise moment that the setting sun reached the horizon.

Leica R4, 35/2 Summicron, 1/125 f4 Kodachrome 25 Professional

(OVERLEAF) TREE, ULLSWATER
The English Lakes are one of my favourite areas. If the weather looks interesting I will set off on the two-hour drive to arrive soon after dawn, when the water is still and the morning mist gives atmosphere. From experience I know good viewpoints. This avoids wasting time when the light is right.

Leica R4, 35/2 Summicron, 1/60 f4 Kodachrome 25

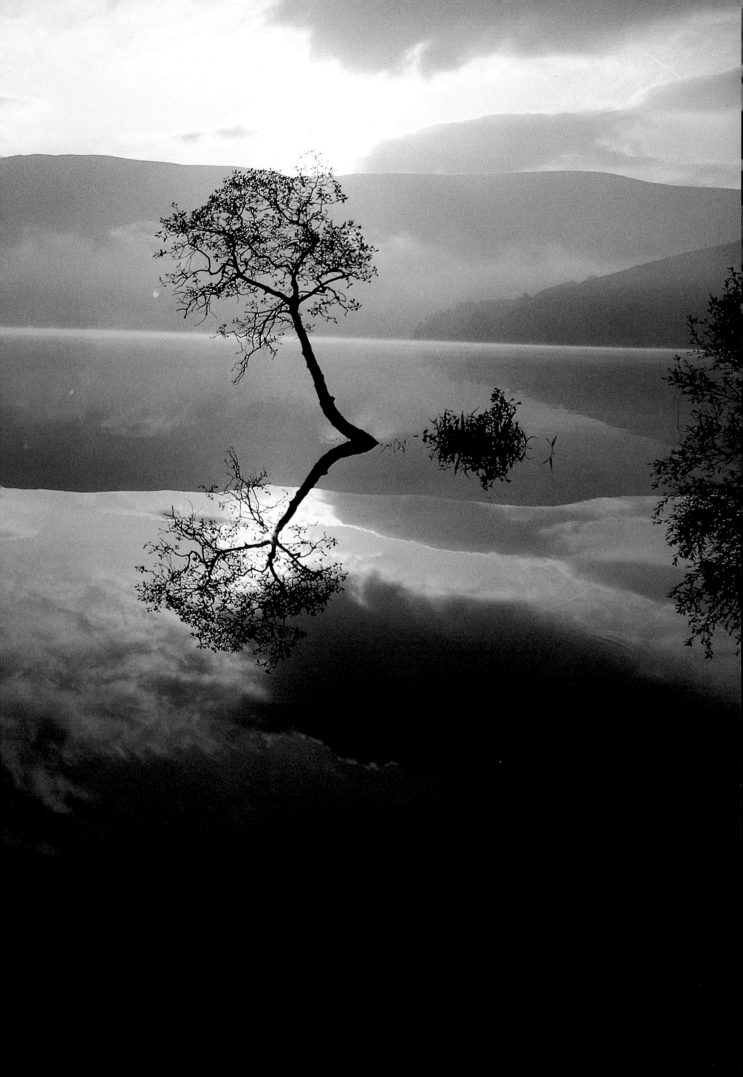

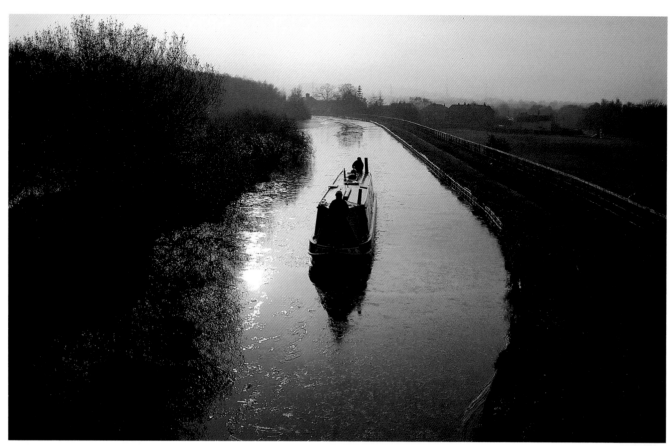

NARROWBOAT
These two pictures of
the same boat were
taken within a few
minutes of each other.
I was standing on a
small bridge over the
canal and took the first
shot against the light as
the boat came towards
me, picking its way
through the thin ice.
The second shot, taken
after it had passed, was
with the light behind
me. The remarkable
difference made by the
direction of the light is
particularly obvious
here.

Leica R5, 35/2
Summicron, 1/125 f5.6
(against the light) and
1/125 f4
Kodachrome 25
Professional

LIGHT

A major difficulty, of course, is that you have no control. The subject is fixed – you cannot move mountains or buildings around to make a better picture – and the most important element of all, the key to all photography, light, is essentially that supplied by nature and cannot be controlled either. The time of year, time of day and weather are all factors that enter into the lighting equation, enormously affecting the mood of a scene. It is for the photographer to understand and develop a feeling for these factors if he wishes to create something more than a straightforward record.

Early morning, late afternoon and early evening are usually the best times for landscape photographs. The light has a marvellous soft quality yet the low angle of the sun throws details into relief, adding a three-dimensional effect. This is particularly striking when the light is coming strongly from the side, or especially when you shoot directly into the light.

WEATHER

Just before and just after a storm are the best times for dramatic effects, with glowering skies acting as backdrops to hills or buildings spotlit by a last burst of sunlight.

Skies of all kinds are a vital element in any landscape and time taken to gain an understanding of weather patterns and clouds will be well repaid. The ability to read a weather chart is as valuable to landscape photographers as to those concerned with sailing or flying.

GRAND CANYON IN
WINTER
Patience is an essential
virtue for landscape
photographers. I had
always wanted to
photograph the Grand
Canyon with snow,
and when I arrived to
find the canyon
blanketed in cloud I
was bitterly
disappointed. After two
hours I was about to
give up, but then the
cloud began to lift.
Then, for a period of
less than an hour,
conditions were
absolutely perfect and I
shot two full rolls of
film trying different
lenses and viewpoints.

BELOW:
Leica R4, 35/2
Summicron 1/60, f4
Kodachrome 64
Professional
OVERLEAF:
Leica R4, 21/4 Super
Angulon, 1/60 f8
Kodachrome 25
Professional

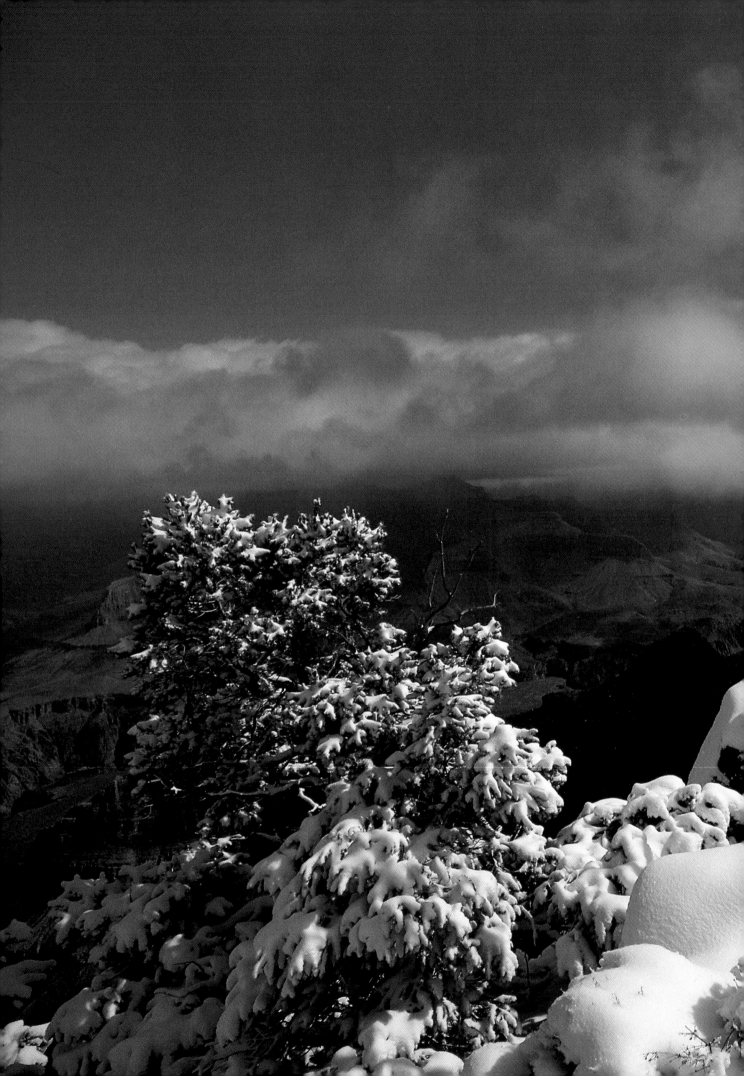

OPPOSITE ABOVE:
RAINBOW NEAR DOLLAR,
SCOTLAND
Adverse weather
conditions will often
produce exciting
lighting. Driving
through heavy rain
showers, a patch of
sunlight produced this
perfect rainbow. I
struggled to find an
interesting viewpoint
before it disappeared
and even the 21mm
lens could not quite get
it all in. Nevertheless, I
was pleased with the
result. It is important
not to overexpose dark
skies, otherwise the
atmosphere is lost.

Leica R4, 21/4 Super
Angulon, 1/60 f8
Kodachrome 64
Professional

SEASON

Places are often much more interesting 'out of season'. Late autumn and winter are favourite times for me. It is amazing how a touch of morning mist or a fall of snow can magically transform a normally ordinary scene. Spring brings changeable weather, fresh green growth and often a clear atmosphere for distant views. Summer heat encourages the development of thunderheads which produce the dramatic storms referred to earlier.

PLANNING

Relatively few good landscape photographs are achieved by pure chance. Luck often does play a part, but this is frequently the final element which combines with a lot of planning and experience, together with much patience, to put you in the right place at the right time.

If you know an area well and can revisit easily this is a great advantage. You will have a store of viewpoints locked in your memory waiting for just the right day. When working further afield, spend time ahead of your visit studying detailed local maps and tourist brochures so that you have some idea of what you are looking for and where to find it, and when the light will be most favourable. Then if the 'magic moment' does arrive you will be ready to take advantage of it.

OPPOSITE BELOW:
THE HEAD OF
ULLSWATER
Taken late one winter's
afternoon. The low
lighting of this time of
year makes a far more
interesting picture than
a typical summer
scene.

35/2 Summicron, 1/30 f11
Kodachrome 25

MAPS
Large-scale detailed
maps are an essential
for the landscape
photographer in order
to work out light
direction and
viewpoints

SUNRISE, MONUMENT VALLEY
You have to be up early to get the best pictures. This was around 5am! I shot a whole series from the time when the sky began to lighten until the sun was above the horizon.

Leica R5, 100/2.8 Apo Macro, 1/125 f2.8 Kodachrome 64 Professional

LENSES AND ACCESSORIES

The three lenses that I use most for landscape are the 21mm, 35mm and 90mm. A medium wide-angle is strongly recommended (28 or 35) to allow scenes with strong foregrounds and depth of detail through to the distance. A medium telephoto (80/90/100) is needed when you wish to concentrate the interest, eliminating non-essential elements of the scene. A good alternative is the 70–210 zoom. An ultra-wide such as the 19 or 21mm is more of an acquired taste, but with experience it does allow you to create dramatic and unusual compositions. Very occasionally a 180 or thereabouts is useful, but it is fairly unusual to see good landscapes from very long lenses.

The most useful accessories are three filters referred to in an earlier chapter (polariser, 81b, graduated grey). The polariser is especially valuable. Blue skies can be darkened whilst contrast and colour saturation in the landscape can be increased. The graduated grey can be used to avoid pale sky areas 'washing out', whilst the 81b will help to keep colours from going blue on dull days or in the shade.

SHARROW BAY
Another early morning view taken in the English Lakes. This particular picture demonstrates how careful use of the fisheye lens – making sure that the horizon line is in the centre of the picture so that it is not curved – can be very effective.

Leica R4, 16/2.8 Fisheye, Elmarit 1/60 f5.6 Kodachrome 25 Professional

TRAVEL

Whether it's travel that stimulates an interest in photography or photography that encourages travel is difficult to say. What is certain is that, like many artists, photographers find new places, new subjects and a different kind of light very stimulating. It is worth taking trouble to make the most of travel opportunities.

PLANNING

Good planning is absolutely essential. The where, when and how need to be considered at an early stage, especially if you are making that 'trip of a lifetime'. Thorough homework will enable you to make the most of what is always too little time.

This is not to say that you want to be organised for every moment of your trip. The secret of good planning is to have a definite overall strategy to ensure that you get to the right places at the best times, yet also to allow plenty of slack in your programme so that when everything is just right you can concentrate on your picturemaking without feeling pressured by a strict timetable.

Photographically speaking, the height of the holiday season is rarely the best time to visit anywhere – quite apart from the crowds, which can be very inhibiting, weather and light are often much more attractive slightly out of season. Endless clear blue skies may be fine for basking on the beach or by the pool but can soon become very boring pictorially.

Interesting skies and subtle atmospheric lighting are what the photographer needs, and in Europe and North America you are more likely to get these in May and October than July and August. Beware of the time clichés too. Paris is beautiful in April, but it's even more attractive in October and a lot less crowded!

Good guide books (Michelin green guides are recommended if they are available for your destination), national and regional tourist offices and airline brochures are all valuable sources of information. It is well worth investing in good maps and town plans, as a knowledge of the local geography is a prime requirement.

EQUIPMENT

So far as equipment goes, this obviously depends on where your trip is taking you. An African safari naturally demands a somewhat different approach to a hiking tour in the mountains. Specialised requirements apart, however, the recommendations for a good general-purpose kit are as follows:

CAMERAS

Take two bodies if possible. These should accept the same lenses and it helps, but is not essential, if they both accept the same accessories. This means two the same of earlier models or any two of the R4, R5, R6 or R-E series, which take the same motor drive/winder, focussing screens, angle finder etc.

VENICE
Taken early morning in October. Most popular places are better avoided during the main tourist season. May and October are good months in Europe and most of North America, with good light and fewer crowds. The best light for most subjects is early morning, from dawn to about 10am.

Leica R3, 21/4 Super Angulon, 1/125 f5.6 Kodachrome 25

MAPS AND GUIDES
Advance planning pays dividends. Good maps, guides and travel brochures are essential reading

LENSES - BASIC OUTFIT

A 28 or 35mm wide-angle.
A 50mm standard or 60mm macro.
An 80/90mm or the 70–210mm zoom.*

EXTRA LENSES - MORE EXTENSIVE OUTFIT

An ultra-wide-angle (19–21mm).
A longer telephoto (180mm).*
The 2× extender.

ACCESSORIES

UV or skylight filters on all lenses and a polarising filter.
Table tripod – for night shots, interiors etc.
Small flashgun – for fill-in flash.
Blower brush and well-washed cotton handkerchief for lens and camera cleaning. Keep these items in a resealable plastic bag and only use them when really necessary. Frequent and overenthusiastic cleaning of lenses does more harm than good! Spare batteries.

CASES

Nice leather or aluminium cases are fine but there are many places where it does not pay to advertise the fact that you are carrying valuable photographic equipment around. In these situations the preference is to keep the cameras in well-worn, ever-ready cases, the lenses in cases also, and carry the lot around in an ordinary well-worn leather case or travel bag.

The recommendations above will give you a reasonable, portable outfit that will cover pretty well any normal requirement. Do not be tempted to carry too much equipment. Not only does the extra weight slow you down physically but the greater number of permutations of lens/body/accessory lead to indecision whilst those pictures of a lifetime disappear forever! If you feel that the basic lenses that I have listed above are inadequate, remember that Cartier Bresson only ever used a standard lens!

It may seem an obvious comment, but it bears repeating – never go off on a trip with equipment that is completely untried and that you have not practised handling and don't understand how to use. You cannot concentrate on picturemaking when you are fumbling with unfamiliar gear and, worse still, if you handle it wrongly you don't want to find out when your completely irreplaceable travel images are returned from processing.

SPECIAL NEEDS

Obviously specialist branches of photography – eg nature, underwater etc – demand specialist equipment, and the expert is far better qualified to judge his requirements than the author. Certainly on an African safari a 400mm lens would earn its keep, but it's a brute to carry whilst you walk round Salzburg or Venice. If you occasionally need a long lens and want to keep the

PAGES 100–1:
MANHATTAN
A view of the Wall Street area and across the East River towards Brooklyn and Queens. The bridges on the left are Manhattan Bridge and Brooklyn Bridge. Taken from the Port Authority building through a very thick plate glass window. The late afternoon sun and strong side lighting give shape to the buildings.

Leica R5, 21/4 Super Angulon, 1/125 f8 Kodachrome 64 Professional

* If you are taking a 180mm, a shorter medium tele would be a more logical choice than the zoom. This ideally would be a fast lens (eg 80/1.4 or 90/2), but the 90/2.8 or either of the 100mm macros would be almost as useful.

BRYCE CANYON, UTAH
Two of the most useful lenses for travel photography are a medium wide-angle (28 or 35mm) and a medium telephoto (80, 90 or 100mm). The wide-angle sets the scene and the telephoto concentrates on the detail. The upper picture here was taken with the 35/2 Summicron at 1/125 f4 on Kodachrome 25 and the lower one with the 90/2 Summicron at 1/250 f4 on Kodachrome 64. The low early morning (7 am) light throws the landscape into relief, and in the wide-angle shot there is a trace of mist in the distance to enhance the feeling of recession. The figure in the telephoto shot is small enough not to intrude but gives a sense of scale to the rocks

weight down, the 2× extender gives very good results with a 180 (especially the Apo), providing an effective 360mm lens.

FILM

Film is almost certainly best bought before departure from a reliable local supplier. Not only will it be cheaper but you can be sure it has been stored properly. As with equipment, it pays to stick to the films that you know. Don't experiment with emulsions that are new to you and don't forget that there are subtle variations even between UK, US and French-manufactured Kodachrome. Estimate your film requirements generously and then double it. You will find that new surroundings can be very stimulating to the trigger finger. Just remind yourself that it has probably cost a lot of money in transportation and hotels to get you in position for a picture, so why risk all by economising on film? Beware of X-ray machines at airport security checks. If at all possible keep your films in a separate, clear plastic bag and ask for a manual search. Modern low-dose equipment installed at most airports in western Europe or North America is safe for two or three passes, but the effect is cumulative and it is better to avoid problems.

SAILING JUNK, HONG KONG
The sight of a working junk is becoming less and less common. I spotted this one sailing up the harbour as I travelled on the Star Ferry crossing from Hong Kong to Kowloon, and rushed to get off to find a good viewpoint. I needed a 180mm lens to fill the frame.

Leica R4, 180/2.8 Elmarit, 1/500 f4
Kodachrome 64

BUDDHIST MONK, THAILAND
Candid pictures of people are often easier to shoot with a wide-angle lens than a long telephoto. People tend to be less suspicious when you are closer to them and they can see better what you are doing. Once they get used to you being around they soon relax, and often do not realise that you have actually taken a picture.

Leica R4, 28/2.8 Elmarit, 1/250 f5.6
Kodachrome 64

PAGES 104–5:
TAKE-OFF FROM JFK
Pictures en route are always worthwhile. Views of ground features from the air need to be taken whilst the aircraft is quite low. Wide-angle lenses are best as they are less affected by distortion from the thick, double layered perspex windows. A seat forward of the wing should be chosen if possible as this will allow either an unrestricted view or the inclusion of a wing to give perspective.

Leica R5, 35/2 Summicron, 1/125 f5.6
Kodachrome 64 Professional

FIGURES, ROYAL
PALACE, BANGKOK
The buildings and
temples in the Royal
Palace complex in
Bangkok are amazingly
richly decorated. The
whole area is a
photographer's
paradise. In this
instance a medium
telephoto lens was
ideal for isolating
intriguing details such
as these figures.
Lighting from a hazy
sun was perfect.

Leica R4, 90/2
Summicron, 1/250 f4
Kodachrome 25

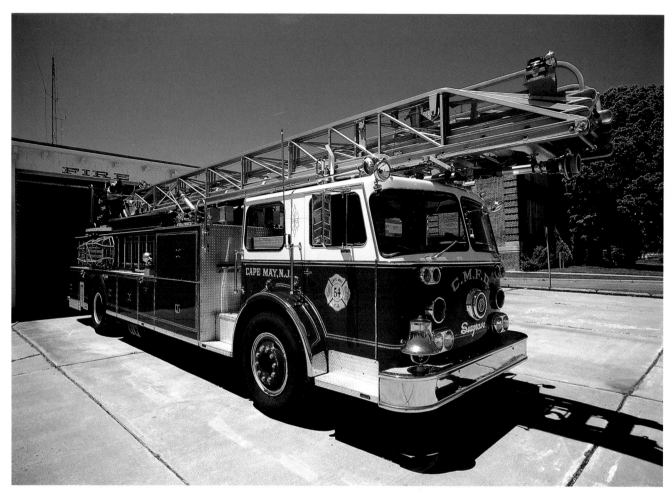

FIRE ENGINE, CAPE MAY, NEW JERSEY
On a visit to southern New Jersey I just could not resist this beautifully polished, bright red fire engine. The 21mm lens enabled me to achieve a suitably dramatic perspective and allow the main subject to dominate the rather distracting background.

Leica R4, 21/4 Super Angulon, 1/60 f8 Kodachrome 25 Professional

PICTURE OPPORTUNITIES

However you travel you will find plenty of opportunities for pictures en route, at airports, in the air, on board ship or train, and in cars where you can take wide-angle shots from the back seat including both driver and scenery ahead, eg a customs post or car ferry. If you are contemplating putting together any form of slide show, signs of all kinds make useful 'link' items, conveying information without labouring the point. If carefully chosen and photographed they can be both colourful and amusing too.

In completely different surroundings it is very easy to be so taken up with novelty as to forget good photographic technique. Certainly original subject matter is fascinating in itself, but how much more interesting and exciting it can be if you apply your skills in composition and lighting, choosing just the right lens and just the right moment for your picture. In well-known locations it is often worthwhile having two bites at the cherry, if you have the time. First have a look round the sights to see them and maybe take one or two basic 'records' that will enable you to get the clichés out of your system. You can then return later in your visit, somewhat less stunned by the newness of it all and having a much better idea of the best angles and the right time of day for the best light.

The best images seem to come with the magical early morning light, or in the hour or so before sunset. During the summer

KENWORTH TRUCK, ARIZONA
The heavily chromed, highly polished trucks are truly the kings of the US road system. They have always fascinated me on my visits to North America and make great camera subjects. This one was near Flagstaff.

Leica R4, 21/4 Super Angulon, 1/60 f8 Kodachrome 25 Professional

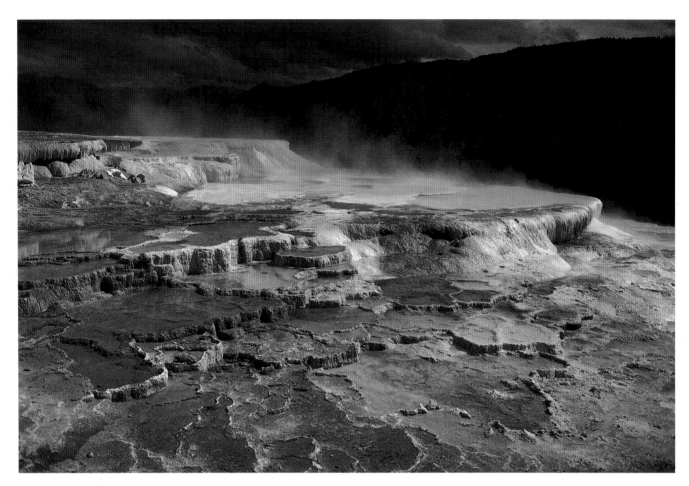

LIMESTONE TERRACES, MAMMOTH HOT SPRINGS, WYOMING
Part of the fascinating geology of Yellowstone National Park. Patience was needed as the sun was very fickle, and I had to wait quite a time for some interesting light.

Leica R5, 35/2 Summicron, 1/125 f5.6 Kodachrome 25 Professional

months, unless the weather conditions are particularly interesting (eg just before or just after a storm), the light in the middle of the day is relatively unproductive of good pictures. Another advantage of getting out and about early is that you avoid the worst of the tourist crowds and can work relatively unimpeded.

Don't forget to take plenty of pictures of the small things that make a place different – street signs, advertisements, typical Americana, etc. People are always interesting. It is worth remembering that it is usually easier to get good candids by working close in with a wide-angle lens than with a long telephoto. I have a theory that there is nothing more conspicuous than a photographer trying to look inconspicuous at the end of a long lens! It is significant that a great deal of today's photojournalism is done with 28mm or 35mm lenses.

CHAPTER 11

NATURE AND WILDLIFE

Interest in nature and wildlife has never been greater and many people wish to use their cameras to add to their interest. Leica SLRs are an ideal tool with several lenses and accessories especially suited to the many aspects of nature photography, from the tiniest plants and insects to the largest mammals and mightiest trees.

Whole books have been written on individual aspects of this topic, so this chapter will act only as a very basic signpost to this most fascinating subject.

PREREQUISITE

To be successful at photographing nature, it is most important to learn about your subject. When appropriate you should not

ROCK ROSE
A straightforward picture to show the details of the flower taken with the 100mm Macro lens in order to isolate the subject from the background. A good solid tripod allowed a reasonably small stop to gain enough depth of field.

Leica R6, 100 Apo Macro, 1/30 f11
Fuji Velvia

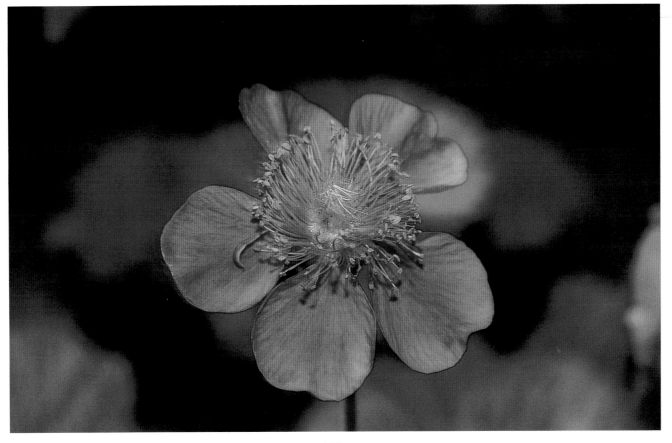

BEAVER TAIL CACTUS,
DEATH VALLEY,
CALIFORNIA
Showing a plant in its
natural environment is
much more
informative to the
viewer. Using a wide-
angle lens allowed me
to picture the cactus
quite large in the frame
yet still include its
desert habitat.

Leica R4, 35/2
Summicron 1/125 f8
Kodachrome 25
Professional

hesitate to seek advice from an expert naturalist and, above all,
you must have respect for your subject and know enough to avoid
disturbance and damage to it and its environment. The safety and
welfare of the wildlife that you wish to photograph should be
your first priority. Many species of both wildlife and plantlife
have a very precarious existence and no photograph is worth
threatening their survival.

PLANTS AND FLOWERS

These subjects stay put and once you have found them the photo-
graphic method is generally a straightforward application of
close-up technique (see Chapter 7). Try to isolate the subject
from distracting elements in the background, either by judicious
use of depth of field to keep the background well out of focus or by
shooting from a carefully selected viewpoint. Don't forget to use
the preview lever to assess the effect accurately. Provided that no
environmental damage will result, a certain amount of 'garden-
ing' with a pair of scissors can eliminate distracting grasses and
stalks.

A modern approach is to show wild flowers and plants in their
environment. Not only is this informative but it can be very
attractive pictorially. A 28mm or 35mm lens is usually best but
sometimes even a 21mm can be used to dramatic effect.

BIRDS

This is highly specialised photography. Although garden birds and some seabirds can be photographed with nothing more complex than a long lens and much patience, many species demand ornithological expertise, the use of a hide (blind) and considerable local knowledge.

For the more straightforward subjects you need at least a 250mm lens, but very often a 400 or even a 560 will be a necessity. Even as close as 3.6m (12ft; the nearest normal focussing distance of a 400/6.8 Telyt) a small bird will occupy less than half the frame. With both the 400/6.8 and the 560/6.8 Telyts the 60mm extension tube is a useful accessory to allow a closer approach. For these more accessible birds you can improvise a hide by shooting from a garden shed window, or a car window. Another possibility is to set the camera up on a tripod focussed on a favourite perch and then operate the camera with a motor drive and remote release.

It is worth remembering that many of the better zoos and wildlife parks provide excellent natural facilities for some species of birds. There are also falconries, where birds are trained for such tasks as keeping airfields and airports clear of flocks of birds that can cause damage by being ingested into jet engines. Many of these falconries are open to visitors and, together with zoos and wildlife parks, they offer an excellent opportunity to practise bird photography in more predictable conditions than in the wild. You can practise handling long lenses, avoiding camera shake and focussing quickly and accurately. You can also get used to the distances that you can work at and the focal length required to achieve a satisfactory image size at these distances. In addition, the falconries will offer a chance to try shots of birds in flight as they return to their handler.

This is not true nature photography, of course, but it is possible to make attractive photographs, and you can also gain valuable experience that will help you avoid wasting precious opportunities when you are truly in the field.

THE 400/6.8 TELYT
This is an excellent lens for bird and wildlife photography. It is light, portable, quick to focus and very comfortable to handle

CHAFFINCH
I photographed this small bird using my car as a hide. Even though I was quite close with the 400mm lens the bird is still small in the frame.

Leica R4, 400/6.8 Telyt, 1/500 f6.8
Kodachrome 200 Professional

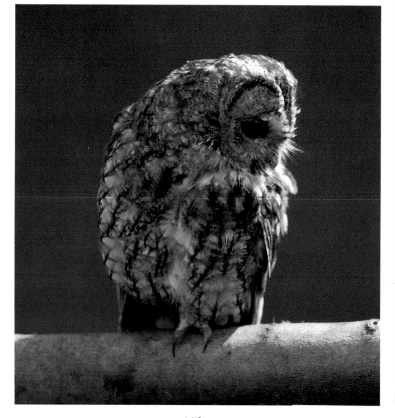

SLEEPING OWL
Zoos and falconries offer useful opportunities to practise bird photography. I was able to get close enough to this owl to use a 135mm lens. Although I was shooting through a wire mesh, using a fairly wide aperture ensured that this was sufficiently out of focus not to be disturbing.

Leicaflex SL 135/2.8 Elmarit 1/250 f5.6
Kodachrome 64

112

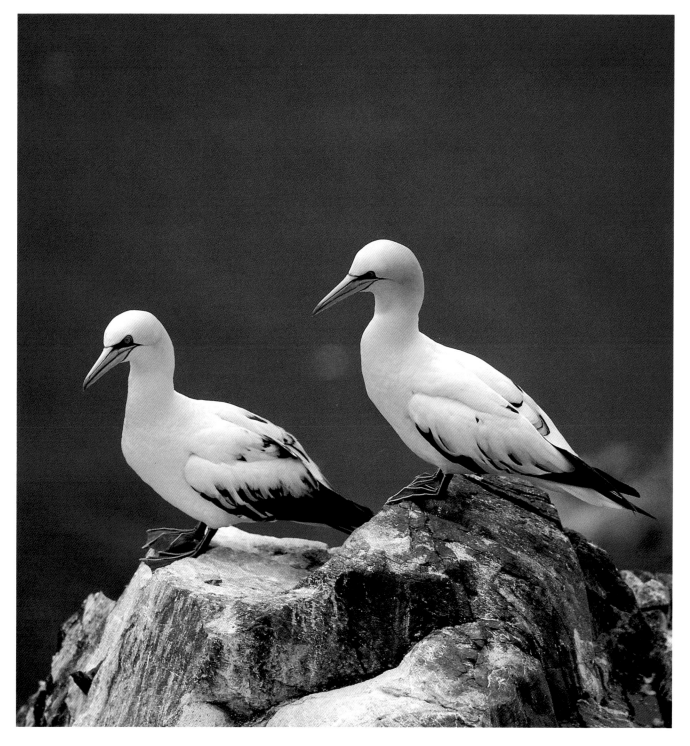

IMMATURE GANNETS, BASS ROCK, SCOTLAND
The Bass Rock is one of the world's major gannet colonies and the birds are relatively easy to approach and photograph with a moderate telephoto. I was fortunate with the lighting. The sun was diffused by a thin layer of cloud which helped to avoid the problem of loss of detail in the white feathers.

Leica R4, 280/2.8 Apo Telyt, 1/500 f4 Kodachrome 64 Professional

INSECTS

Insects, butterflies, beetles, spiders etc demand the utmost in close-up technique. Most pictures are in the 1:1–1:4 range with consequent severe limitations of depth of field. Not only this, but the subject moves.

Focus has to be placed very accurately to make the most of what is available. Even at f16 the depth of field at 1:2 (half lifesize) is only 6mm (¼in) and at 1:1 (lifesize) it is only 2mm ($^1/_{12}$in). You need to position and angle the camera so that as much as possible of the subject lies within this band of sharp focus. A particular difficulty can be subject movement due to the wind agitating the plants, bushes etc where the insect is resting or feeding. Early morning or evening are times when the air is likely to be stiller.

Loss of light at higher magnification, the need for small stops and the necessity to avoid blur caused by subject movement or camera shake often mean that electronic flash is very worthwhile. The TTL flash metering of the R5, R6 and R-E is a great help for this. It is worth knowing that with the 100mm macro lenses there is sufficient clearance between lens and subject to allow a hot shoe-mounted gun to be used quite effectively, although the light is a little 'toppy'.

If you get seriously interested in insect photography the bellows unit is especially convenient. The 100mm Elmar lens head is probably the most useful optical combination, although the unit does offer many other possibilities including use of the 65mm V Elmar, which allows focus from infinity to 1.5× lifesize. The special Macro Flash unit would complete a very comprehensive outfit.

ORANGE TIP BUTTERFLY
Many butterflies settle when the sun goes in and it is possible with care to approach quite closely without disturbing them. Working without flash and hand-holding the camera – as here – gives a much more natural result, but to avoid camera shake an absolute minimum shutter speed of 1/60 sec was needed with the 60mm lens, and this meant f8. Depth of field was very limited and great care was needed to keep as much as possible of the butterfly in the plane of focus.

Leica R4, 60/2.8 Macro Elmarit, 1/60 f8 Kodachrome 64 Professional

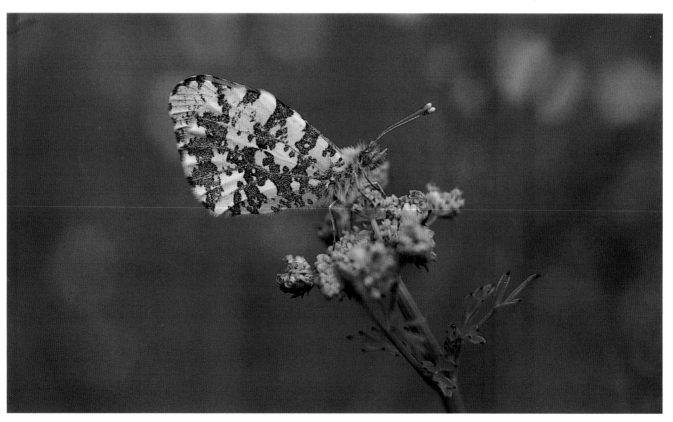

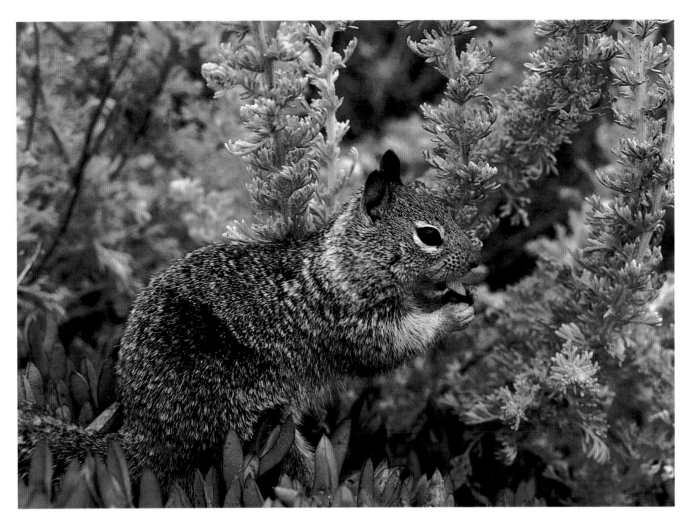

MAMMALS

This category could include anything from a mouse to an elephant but it is the big game of Africa and parts of America and Asia that tends to capture the imagination. There is a unique excitement when you meet these beasts on their own territory for the first time and everybody wishes to capture them with their camera.

You will normally be shooting from some kind of vehicle and with many animals it is possible to get fairly close. One of the 180mm lenses or the 70–210 zoom would be excellent. If you also take a 400mm (or a 2× extender) you will be able to handle most opportunities. These animals are most active in the very early morning and early evening, when light levels are lower, so at these times you will need the fastest lenses whenever possible and a film of reasonable speed – ISO 200 or ISO 400. In the middle of the day one with a speed between ISO 50 and ISO 100 will be best.

Take a well-padded outfit case. A four-wheel-drive vehicle in the bush or wilderness is a harsh environment for valuable cameras and lenses. Some kind of support for long lenses can be useful – the universal handgrip, a monopod or a beanbag would be worth taking along and a motor drive or winder is a great help in fast-changing situations or when handling long lenses.

AMERICAN GROUND SQUIRREL
This little fellow was photographed at Point Lobos in California. Here and at other places where I have seen these squirrels they seem fairly unperturbed by people, and it is possible to get close enough to make pictures with only a medium tele such as a 135 or the 90 used in this instance.

Leica R5, 90/2 Summicron, 1/250 f5.6 Kodachrome 64 Professional

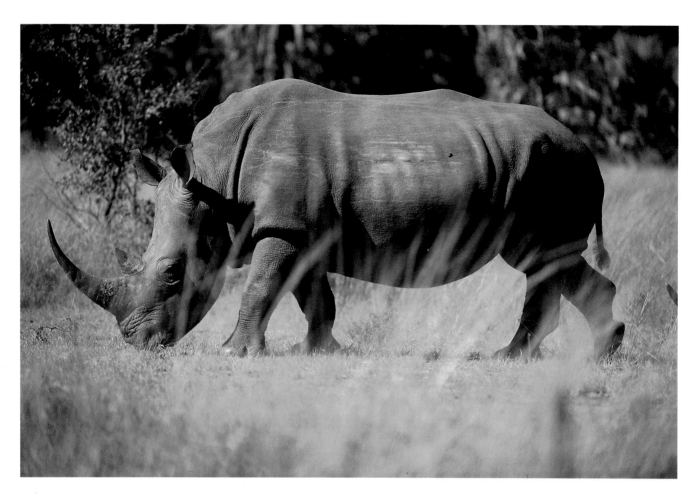

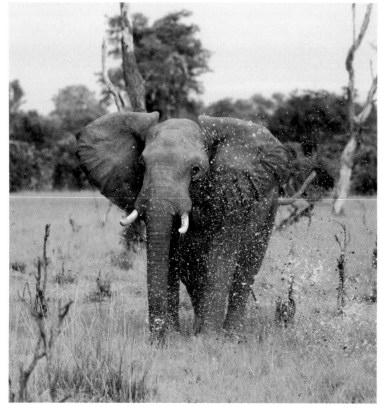

RHINO, ZAMBIA
For wildlife photography in Africa one of the 180mm lenses (or the 70/210 zoom) is particularly useful. Ideally this should be accompanied by a 400 or 500mm for the occasions when an animal cannot be approached too closely or for photographing birds. Mostly you are working from a vehicle so that positioning is not always easy. I was not inclined to get out to avoid the grasses in front of my lens!

Leica R4, 180/2.8 Elmarit, 1/500 f5.6
Kodachrome 64

ELEPHANT, ZAMBIA
African elephants can be very dangerous when angry or frightened. This one had got separated from the herd and was not at all happy. He was flapping his ears, trumpeting and stamping his feet in the marshy ground so our driver was preparing to beat a hasty retreat. My longest lens was the 180/2.8 but with the 2× extender this gave me a 360 equivalent. For the late afternoon light I had loaded with a fast film so that the loss of two stops with the extender was acceptable.

Leica R4, 180/2.8 Elmarit plus 2× extender, 1/500 f2.8 (equal to f5.6)
Ektachrome 400

CHAPTER 12

FILM

Leica lenses are not only very sharp but also provide superb tonal gradation and colour quality. To make the most of these qualities the right film must be used. Given the bewildering variety available in 35mm, the choice is not easy. Each make has its own characteristics. The skilled photographer will appreciate these and get to know thoroughly a small selection of films appropriate to his or her particular needs.

The films mentioned below represent only a few of those available, but include examples which are widely available and of known and consistent performance.

SLOW FILMS

The finest quality comes from the slowest films (ISO 25–ISO 64). The Leica user has the great advantage of lenses that deliver performance even at the widest apertures, allowing confident handheld use of these films in most daylight situations. If light levels are lower or you need to stop down well for depth of field (eg in close-up photography) a tripod will probably be necessary, but this is often a small price to pay for top quality.

MEDIUM-SPEED FILMS

Films around the ISO 100 speed are a good compromise. With black and white, and also to a large extent with colour negatives, the gain from using a slower film is less dramatic than with colour transparency. Negative films are in any case more tolerant of exposure and processing errors and the extra speed reduces the risk of camera shake or allows more depth of field. If you want prints, therefore, a film from this group would be a good choice.

FAST FILMS

These range from ISO 200 to as fast as ISO 3200. Clearly there are occasions when you need every bit of speed you can get, but the rule should be to use the slowest film that will do the job. In practice it is rare that ISO 400 or even ISO 200 is not fast enough. There is a significant drop in quality beyond ISO 400.

COLOUR TRANSPARENCY FILMS

For the absolutely highest quality and particularly for colour reproduction on the printed page, transparency (colour slide) films are best. They are sharper and finer-grained, and there is no way that even the very best print can handle the range of tones and contrasts that a transparency can. If you wish to sell your work for publication, you must shoot slide film.

The obvious disadvantage of slides is that you need some kind of viewer or projector to look at your work. Less obvious disadvantages are that the process is far more demanding technically. Not only is the frame taken in the camera the final result, with little opportunity for cropping and none at all for shading, lightening or darkening at a printing stage, but the film itself is far less

117

UNIVERSAL STUDIOS,
LOS ANGELES
Kodachrome 25 is the
slowest of the popular
colour slide films but it
has an enviable
reputation as the
sharpest and finest-
grained of all. Its
ability to render fine
detail and the excellent
colour balance are
apparent in this picture
of a set at Universal
Studios.

Leica R4, 28/2.8 Elmarit,
1/125 f5.6
Kodachrome 25

tolerant of exposure errors. For the best results you have to be accurate to plus or minus a quarter stop. Essentially you have to do your work out in the field, not in the darkroom.

Because of the inability to correct at a printing stage, it is also necessary to use a slide film balanced for daylight (this is suitable also for electronic flash) or for tungsten (artificial) light. The latter is mainly used with studio lighting or stage photography, but in practice these days most professional studios use daylight-balanced electronic flash, whilst modern stage productions and artificial light out of doors are such a mix of types and colours that you are as well off with daylight-balanced film, which is generally faster anyway.

It is almost impossible to say which is the 'best' colour transparency film. So much depends on the subject matter and the photographer's perception of, and taste in, good colour. The following comments based on extensive experience of all the films mentioned may be helpful, but the important things are to find a film (or group of films) that suits you and your favourite subjects, really get to know it, and stick with it so that you can concentrate on your subject rather than on which film to use.

At the time of writing, Kodachrome 25 is still the sharpest and finest-grained, with superbly smooth gradation, excellent landscape colours and good flesh tones. It is the standard by which others are judged, but you have to learn to live with ISO 25! Fuji Velvia is the sharpest and finest-grained E6 process film yet, and directly competitive with Kodachrome 64 which is an excellent

HOT AIR BALLOON, BATH
Medium-speed films can give a useful reserve of speed for action photography or when light levels are lower; in the early morning, or towards evening as here.

Leicaflex SL2, 180/3.4 Apo Telyt, 1/500 f3.4 Ektachrome 100 Professional

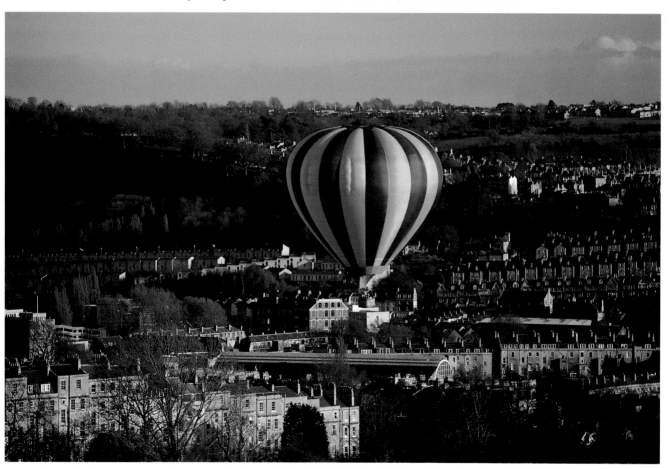

WIND SURFER
When using long focal length lenses or the 2× extender, a faster film is needed to cope with the smaller apertures and higher speeds necessary to avoid camera shake or stop action.

Leica R5, 280/2.8 Apo Telyt plus 2× extender (equal to 560/5.6), 1/1000 f4 (equal to f8) Kodachrome 200 Professional

film but contrastier and lacking some of the more subtle qualities of its slower twin, Kodachrome 25. Velvia, like all Fuji slide films, has strong saturated colours, brilliant reds and deep blue skies and rather brash greens. Fine for many subjects but not ideal for landscapes. Flesh tones are warm, which some find flattering.

The various Ektachrome 100 films offer a neutral colour balance, very smooth tonal quality and fine grain, with good landscape colours and flesh tones. Ektachrome 100 Plus (or HC in the amateur range) has higher contrast and more saturated colours for advertising and commercial work.

The Agfa films of ISO 50 and ISO 100 speed are now E6-compatible and are available in professional and amateur versions. They are commendably neutral in colour balance with nice clean whites and greys.

Kodachrome 200 is remarkable. Although graininess is not significantly different from other films of this speed, it is incredibly sharp. A little on the warm side, but this is no disadvantage on dull days.

Fuji and Kodak ISO 400 films are quite remarkable considering their speed. However, it should be recognised that films faster than this inevitably represent a very significant trade-off of quality for speed and should be used only when absolutely necessary.

Finally, it is worth remembering that you can obtain excellent quality colour prints made from transparencies. Ilford Cibachrome, which is the most permanent of any colour print material, is a popular home process as well as being available from specialist labs. Kodak and Fuji also offer reversal papers for printing from slides.

EARTHA KITT ON STAGE
Although in theory an artificial light film is required for night or stage photography, lighting is so mixed that daylight film such as the Kodachrome 200 used here is often just as effective.

Leica R6, 90/2 Summicron, 1/125 f2 Kodachrome 200 Professional

LITTLE MORETON HALL
A beautifully preserved Elizabethan building in Cheshire, England. The picture demonstrates the excellent sharpness and vivid colours of this E6 process film from Fuji.

Leica R6, 21/4 Super Angulon, 1/125 f8 Fuji Velvia

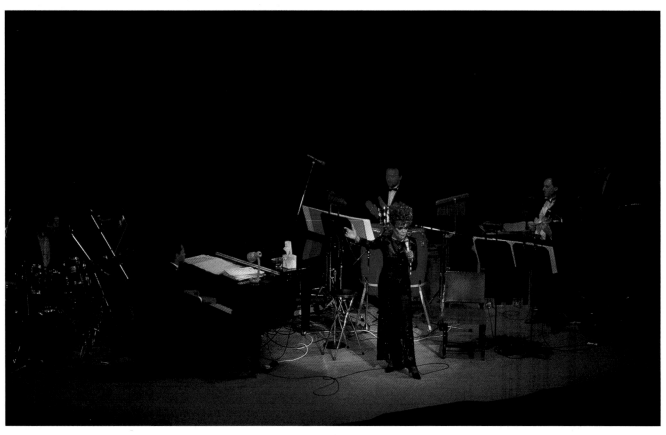

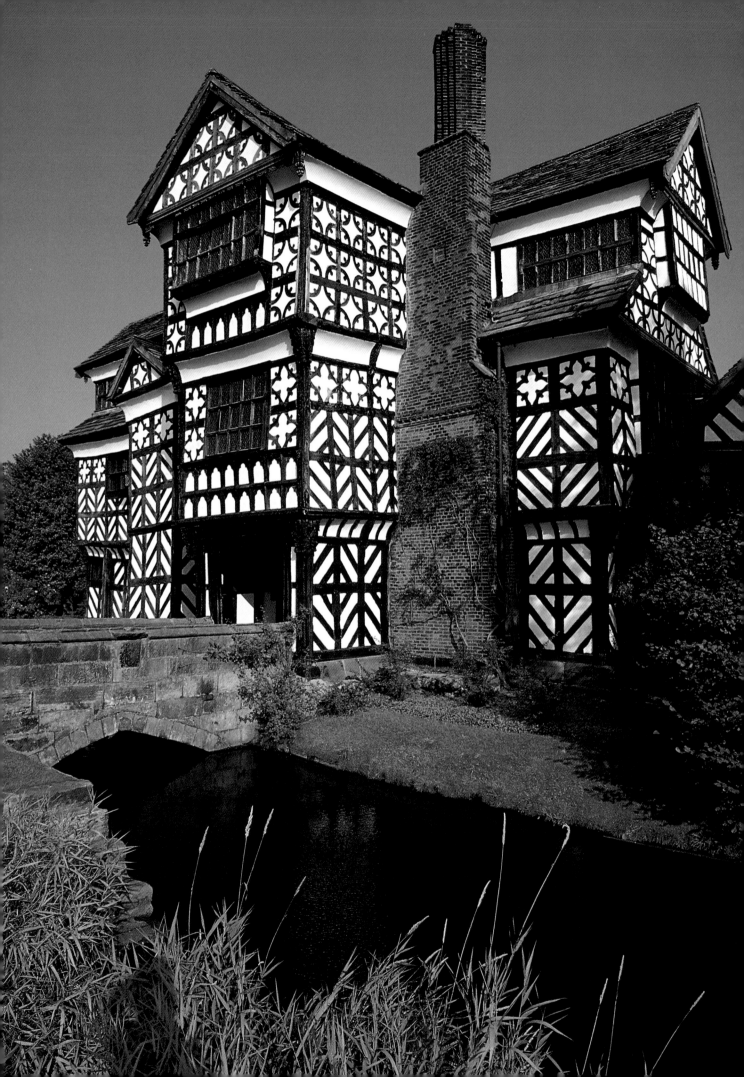

TEST SECTION
Fuji Reala is a new colour negative film where response is claimed to be similar to that of the human eye. Fluorescent lights usually record green but in this picture the fluorescents, used in conjunction with flash-fill to illuminate the foreground, have recorded naturally.

Leicaflex SL2, 21/4 Super Angulon, 1/2sec f8
Fuji Reala

COLOUR NEGATIVE

Enormous improvements in quality and reductions in cost have established colour prints from negatives as the mass market for colour photography. Most colour negative films are designed for the snapshot market, with bright colours and high tolerance to exposure and processing errors. The Leica photographer, however, will be looking for something a cut above the rest. There is an incredible range of films available with standards of processing and printing that go from abysmal to outstanding.

For what it is worth, there are three colour negative films that I use regularly. Ektar 25 (ISO 25) is the ultimate for sharpness but certainly requires as much care with exposure as transparency films. Fuji Reala (ISO 100) is an excellent all-round film with moderate contrast, a good natural colour rendering (even of fluorescent lighting) and quite sharp. Where real speed is required, Ektar 1000 gives excellent sharpness for such a fast film but obviously it is not an appropriate choice for general photography. I use a reliable local professional lab for processing.

More generally, an ISO 100 or ISO 200 film from any of the major manufacturers – Agfa, Fuji or Kodak – would be a good choice. Most important, however, is to find a reliable lab that understands your needs and has good quality control.

FILM

BLACK AND WHITE

There is still a remarkable amount of black and white photography being done. Certain areas of professional photography, and discerning amateurs, are very active in this medium.

Films are incredibly good. There are films of ISO 25–50 that deliver absolutely flawless quality, but even medium-speed ones around the ISO 100 mark – such as Ilford FP4 and Kodak T Max 100 – will provide superb quality in very large prints. Surprisingly, the ISO 400 emulsions from Agfa, Fuji, Ilford or Kodak also allow almost equal sharpness, although there is a noticeable increase in graininess.

Most photographers working with black and white prefer to process and print their own films. The important thing is to establish a film/exposure index/developer combination that suits your method of working and stick with it, so that you can rely upon getting negatives that are easy to print for maximum quality. I mention exposure index because some developers enhance film speed, and some photographers prefer negatives obtained by giving slightly more exposure but with reduced development times.

CHROMOGENIC FILM
Ilford XP1 is a remarkable film. Based on colour technology, it gives excellent quality over a wide range of exposure indices. It can be developed in the standard C41 process. Normal speed is ISO 400 as used here.

R4 with motor winder, 180/3.4 Apo Telyt, 1/1000 f8
Ilford XP1

OVERLEAF:
HOUSE 'BOULDEREIGN', CAREFREE, ARIZONA
Professional films offer consistent reliable quality. Processing needs to be of an equal standard. E6 films should be sent to a good professional lab. Kodachrome Professional films get special attention at Kodak's own labs.

Leica R4, 35/2
Summicron, 1/250 f5.6
Kodachrome 25
Professional

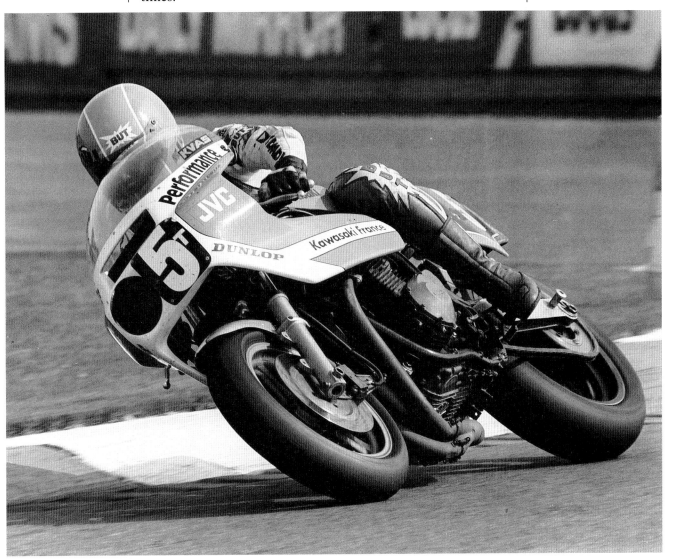

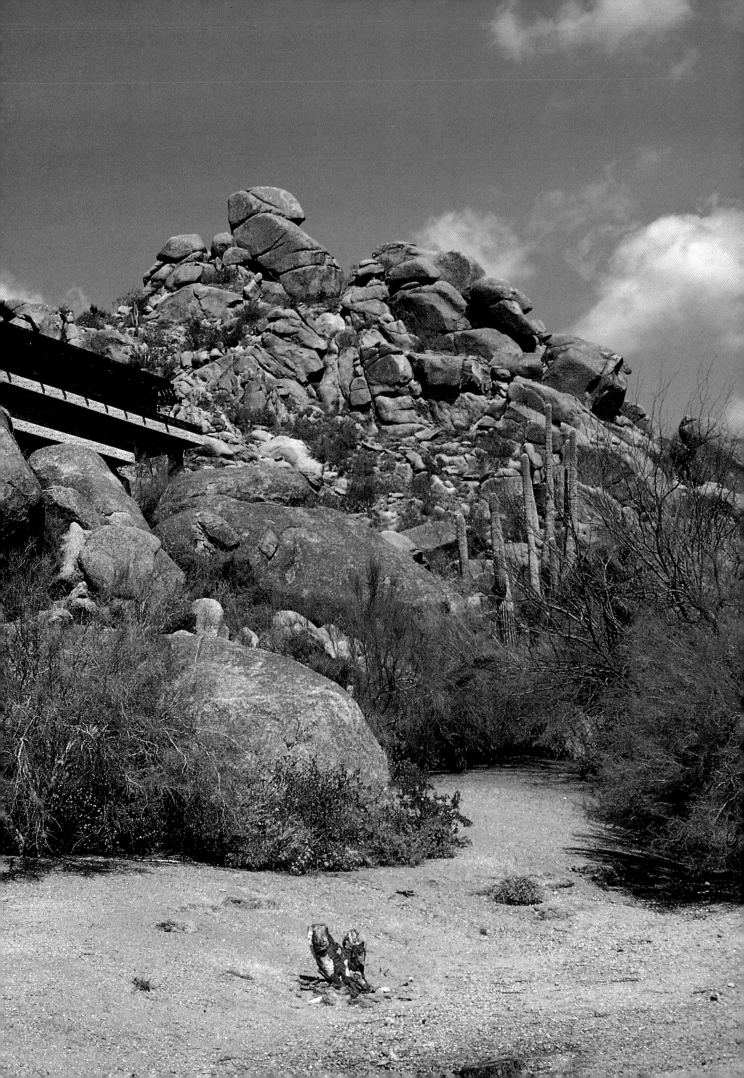

Some reliable, well-tried developers are:

ILFORD ID 11 AND KODAK D 76	Virtually the same formula – best diluted 1:1 and used once only
KODAK TECHNIDOL	Special liquid developer for Kodak Technical Pan film
AGFA RODINAL	Liquid developer used very diluted and once only
HC 110	Another liquid developer used very diluted and once only

With respect to development times/temperature, the film or developer manufacturers' recommendations for a medium-contrast negative are a good starting point. With experience you may wish to modify these factors to suit your own exposure and printing technique or a particular type of subject.

Mention should be made of Ilford XP1, which is a black and white film but one that works technically in a similar way to colour negative. Although normally ISO 400 the film has particularly wide latitude and can be used at a range of exposure indices without loss of quality. When rated at slower speeds, eg ISO 100 or ISO 200, contrast and grain are reduced. The film is processed in its own special developer or the standard C41 colour negative process, so it can be handled by any minilab for easy, quick development and printing. When printed on colour paper the images are in a quite pleasant sepia tint.

PROFESSIONAL FILM

Kodak, Fuji and Agfa all offer a range of professional films. In some cases (eg Kodachrome) these are identical emulsions to the standard amateur film but from batches specially selected for minimum deviation from speed and colour tolerances. Many, however, are produced to meet specific professional needs. Films such as Vericolor III colour negative are of inherently low contrast to facilitate studio and wedding portraiture. Special films are also available for such things as aerial photography or slide copying.

With the exception of Kodachrome Professional (which receives special attention at the Kodak plant), all professional transparency films are E6 process and sold without the cost of processing included. This presupposes the use of a good professional lab – essential for top results – where it is usually possible to get a two-hour service.

Professional films are also distributed through a highly controlled system. All films mature but in the case of professional films they are released from the manufacturers' stocks when they are at optimum, and are stored under closely controlled conditions (usually below 50°F) at distribution depots and dealers in order to maintain them at this optimum. The photographer needs to store them in a refrigerator and ensure they are processed as quickly as possible after exposure.

Professional films offer more consistent performance and therefore eliminate one variable from the quality chain. They need to be matched by accurate exposure and quality processing if their full benefit is to be derived.

CHAPTER 13

ELECTRONIC FLASH

Over the production period of Leica Reflexes there have been many improvements in flash technology. Not only has the flashbulb virtually disappeared but the facilities available with the latest cameras and electronic units have made flash photography much more convenient, with a very high degree of automation.

CAMERA FACILITIES

Leica cameras from the R4 onwards are designed for use with the SCA 300 or 500 flash systems. The correct adapters are respectively SCA 351 and 551. The earlier 350 and 550 adapters, originally supplied for the R4 and R4s, will not allow the full facilities of the R5, R6 and R-E to be used (see Table F, p133).

The R5, R6 and R-E provide very sophisticated operation including automatic TTL metering with suitably dedicated electronic flash units. On the R5 and R-E the shutter automatically sets to the X synch speed (1/100sec) when the flashgun is fitted and ready to fire.

R4 models will also give automatic setting of the shutter speed to the correct (X) synchronising speed of 1/100sec with suitable dedicated units, but all earlier models (R3, SL2, SL and Leicaflex) require manual setting to the X synch or slower speeds. The R3 and SL2 have the convenient and more reliable hot shoe contact via the accessory shoe, but SL and Leicaflex cameras require a cable to be plugged into the correct 'X' socket.

Note that the 'M' socket on the R3 and earlier models is for flashbulbs only. Incorrect synchronisation will occur if the 'M' connection is used with electronic flash units.

ELECTRONIC FLASH UNITS

Leica does not make electronic flash units itself. However, an enormous selection of camera-mounted flashguns is available from independent manufacturers, ranging from simple low-power manual models to powerful professional units with sophisticated computer and TTL exposure controls.

For practical purposes, even with a compact low-power unit you should look for a model with computerised exposure control. You may only have a selection of two or three stops available to set, but the freedom from having mentally to compute apertures based on guide numbers is well worth the modest increase in cost. Bigger units will not only give you more light but there will be an option of more stop settings (six or more in some cases). The most powerful 'hammerhead' guns are too heavy to mount on the accessory shoe and are fixed to the camera by means of a bracket provided.

SCA 300 and 500 dedicated units are available in the full range of sizes, but it should be remembered that the degree of dedication achieved is dependent on the camera as well as the flash unit. An SCA 300 flashgun, with the 351 adapter that gives full TTL flash metering, auto flash speed setting and detailed finder information with the R5, will synchronise satisfactorily with an R3 or SL2, but none of the other facilities will be available. On the R4 or R4s the unit will activate the auto synch speed setting and flash-ready signal, but TTL metering and associated finder information will be lacking.

Manufacturers of SCA 300 and 500 system flashguns include Braun (Bosch), Cullman, Metz, Osram (Wotan) and Regula. Certain Minolta flashguns will provide dedication with the R4 and R4s, and the limited R4-type dedication with R5, R6 and R-E.

BOUNCE FLASH

Direct flash from the camera can be rather harsh. Softer, more natural lighting with better illumination of the background is achieved by bouncing the light from the flash off ceilings or walls.

FLASH COMPARISONS
These two photographs are a comparison of direct flash and bounce flash – the latter being bounced off a wall and ceiling. Note how the bounce flash gives softer lighting with good modelling and better illumination of the background.

Leicaflex SL, 90/2 Summicron 1/100 f8 Ilford XP1

R6 WITH SCA FLASH UNIT
For fill-in, or when using flash with ambient lighting as a major source of illumination, a camera that does not automatically set the shutter to the standard 1/100sec for synchronisation is more convenient

Most of the better guns allow the flash head to be tilted and rotated to permit this.

More sophisticated units allow part of the light to be aimed directly at the subject by means of a partial reflector or a subsidiary flash. A particular advantage of this is that it enables you to lighten the heavy shadows that sometimes occur on people's faces with bounce flash. TTL metering, or the auto computer sensor on the flashgun, will automatically take care of any exposure correction required.

FILL-IN FLASH

This is used to obtain extra exposure and detail when natural or artificial lighting results in heavily shadowed areas. A typical instance would be shooting somebody's portrait outdoors against the light. Flash can be used to ensure adequate detail in the face whilst retaining an attractive rim effect from the natural lighting. This is achieved most easily with a non-dedicated auto computer flashgun.

The technique is as follows.

Set the camera for the exposure of the general scene, either manually or, in the case of automatic exposure cameras, by the averaging metering mode. Make sure that the shutter speed is slower than 1/125sec but not so slow as to cause camera shake. Use a tripod if necessary.

Note the aperture being used on the camera and set the computer gun for one stop wider (ie, if the camera is set at f8 set the gun at f5.6). This will ensure that the flash exposure lightens the shadows without overpowering the natural light.

It will be apparent now why dedication can be a disadvantage for fill-in flash. TTL flash metering would result in a flash-based exposure, thus destroying the natural effect, and auto switching to the X synch speed prevents proper use and metering of the natural light.

TTL FLASH METERING

The R5, R6 and R-E all have automatic metering of flash exposure through the lens. This measures the amount of light received at the film plane during exposure and shuts off the flash when the amount is sufficient for correct exposure. Any film speed and aperture settings on the flash unit are ignored; it is the actual settings on the camera that matter.

TTL flash metering has many advantages. It is quick and easy to use because you do not have to check any settings on the flashgun, it gives you a clear indication in the viewfinder of whether the flash was adequate, and it is particularly convenient for close-up photography because it automatically takes care of the loss of light at greater image sizes.

Remember, however, that as with the normal metering system on these cameras the TTL reads a particular part of the picture area. If this does not coincide reasonably well with the distance of your subject, incorrect exposure will result. Also, if the metered area is abnormally dark or light some compensation will be required, just as with a daylight exposure.

TABLE F

CAMERA VIEWFINDER DISPLAY WITH ELECTRONIC FLASH UNITS

LEICA R6 VIEWFINDER DISPLAY WHEN SCA 300 OR SCA 500 FLASH UNITS ARE USED

Setting of shutter speed	Before exposure with SCA 351, SCA 551, SCA 350, or SCA 550	After exposure with SCA 351 or SCA 551			
	Flash ready	Flash was adequate:			Flash was inadequate:
		Flash ready immediately	Flash ready after 2 s	Flash ready after some time	
X	⚡ flashes twice a second (2 Hz)	⚡ flashes twice a second (2Hz)	⚡ flashes 2 s at 8 Hz, then at 2 Hz	⚡ flashes 2 s at 8 Hz, off, then at 2 Hz	off, then at 2 Hz
1 s to 1/60 s	⚡ lights continually	⚡ lights continually	⚡ lights continually	⚡ lights 2 s continually, off, then lights continually	off, then lights continually
1/125 s to 1/1000 s	⚡ off	⚡ off			
B	No display (power off)				

LEICA R5 AND R-E VIEWFINDER DISPLAY WHEN SCA 300 OR SCA 500 FLASH UNITS ARE USED

Setting of shutter speed	Before exposure with SCA 351, SCA 551, SCA 350, or SCA 550	After exposure with SCA 351 or SCA 551			
automatic to X when flash is ready	Flash ready	Flash was adequate:			Flash was inadequate:
		Flash ready immediately	Flash ready after 2 s	Flash ready after some time	
	⚡ flashes twice a second (2 Hz)	⚡ flashes twice a second (2 Hz)	⚡ flashes 2 s at 8 Hz, then at 2 Hz	⚡ flashes 2 s at 8 Hz, off, then at 2 Hz	off, then at 2 Hz

LEICA R4 AND R4S VIEWFINDER DISPLAY WHEN SCA 300 OR SCA 500 FLASH UNITS ARE USED

Setting of shutter speed	Before exposure with SCA 351, SCA 551, SCA 350, or SCA 550	After exposure with SCA 351 or SCA 551	
automatic to X when flash ready	Flash ready	Flash was adequate:	Flash was inadequate:
		No indication in finder with R4 or R4s. Check indication on flash unit.	
	⚡ flashes twice a second (2 Hz)		

R3, SL2, SL AND LEICAFLEX CAMERAS HAVE NO FACILITY FOR VIEWFINDER DISPLAY OF FLASH CONDITION, NOR FOR AUTOMATIC SETTING OF SHUTTER SPEED TO X.

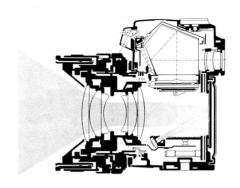

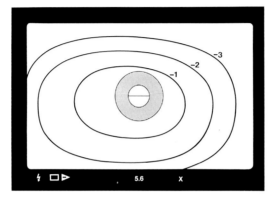

TTL FLASH METERING
PATTERN
The metering pattern
for the TTL flash is
slightly left/centre
weighted averaging

MULTIPLE FLASH

There are many excellent studio flash systems which, obviously, will work just as well with Leica Reflexes as with the larger-format cameras usually found in those studios. This is a subject on its own and beyond the scope of this book. However, I would just say that the quality to be obtained from the Leica and its lenses when they are used in this way can be a revelation to the most blasé professional.

Under less formal conditions a second flash can allow useful control of lighting. This can be achieved relatively simply by setting up one (or more) units on a tripod to give extra modelling or to illuminate the background. Rather than the multiconnections the best way to fire these extra flashes is via a slave unit which triggers when the main flash is fired.

BUYING SECONDHAND

Leica equipment is expensive and this can be discouraging to a first-time buyer who appreciates the quality but has limited resources. In fact a surprisingly large number of Leica users – the author included – start by buying some of their outfit secondhand. Even those buying or trading up to the latest new equipment will also regularly buy used lenses and accessories, and find no disadvantage in doing so.

Leica quality does mean high 'new' prices but it also means that the equipment is built to last. This, together with the care that most Leica users lavish on their valuable outfits, generally ensures good, clean, reliable used items and encourages a sound market.

Naturally, to buy well you do have to know the 'R' system. You also have to recognise the influence of collectors as distinct from users. Because of its history as the first successful 35mm camera, the Leica is probably the most collected of all photographic equipment. This means that certain camera models and lenses command prices that are out of all proportion to their value as photographers' tools. These notes are for those interested in buying a Leica to use for photography, and are intended to provide guidance to the best buys and on points to watch.

CAMERAS

Although the latest model is designated R6 there have been seven Leica SLRs! These are the basic models. Of course there are subspecies within each model, obvious ones – silver chrome, black paint, motorised, non-motorised, etc, and even more subtle variations of fascination only to collectors.

The cheapest way into the system is to buy the manual Leicaflex SL. Although now between seventeen and twenty-three years old, these cameras were built like battleships.

The SL is a much-improved TTL metering development of the original Leicaflex. It features a horizontally running, cloth focal plane shutter of 1 to 1/2000sec, exceptionally bright finder with central microprism circle and very precise narrow-angle spot metering, and it has an excellent reputation for reliability. Nearly all past and present 'R' lenses will fit, but see the tables on pp143–4 as regards lens and metering compatibility. There is no hot shoe and the viewfinder displays shutter speeds and match needle exposure control only.

Later versions with an improved exposure meter cell can be identified by a chrome lens release button rather than red plastic. You can see if an earlier body has had the meter cell up-dated by setting the shutter on 'B' and checking that the cell 'window' has a ridged surface. The standard body does not take a motor or

winder. A few special motorised versions were built but these are collectors' items and, in any case, they are incredibly heavy and bulky.

Points to watch out for when buying are that the meter is working correctly – if it isn't, first check the battery (use Mallory Duracell PX 625 or Varta Pertrix 7002, *not* other equivalents as these may have a slightly different shape and not give a good contact). Check that there is no staining around the edges of the finder – this is an indication that the balsam cementing the finder components together is deteriorating. Make sure that the winding mechanism operates smoothly and if possible check the shutter by exposing a short length of film at speeds from the 1/2000 setting downwards on an area of even tone, eg a clear blue sky (if you are lucky!) or the Kodak grey card. Look for even exposure across the frame, particularly at the 1/2000 and 1/1000 settings, and listen to the shutter on the slow speeds. There should be no stuttering by the escapement mechanism.

Unless the camera has been serviced within the last two or three years you are unlikely to get a perfectly even and accurate 1/2000, but the other speeds should be satisfactory. If not, a full service and adjustment by Leica is likely to be needed and this could be expensive, especially if any parts are required. If in doubt make sure that you get a guarantee. Some official Leica specialist dealers offer cameras that have been checked and certified by the Leica Service Agency, which relieves some of the worry of course.

For those who feel that automatic exposure control is an essential requirement, the R3 is the cheapest option. This was introduced in 1976. A solidly built camera, it offers manual and automatic exposure control. The latter is aperture-priority only but Leica introduced switchable spot and averaging metering modes. Spot metering has a very convenient AE lock operated by slight extra pressure on the shutter release button.

The basic R3 does not accept a winder but the later R3 MOT could be fitted with an excellent 2FPS winder. The Copal/Leitz vertical running, metal-bladed electronic shutter is speeded to 1/1000 and can be set manually down to 4sec, whilst in auto the electronics may set even longer times accurately. If the batteries fail a mechanical shutter speed of 1/100sec is available. Finder information indicates both aperture and shutter speed, and the non-interchangeable screen is the popular split-image/ microprism type.

The R3 is not so convenient and comfortable to use as the R4 but it is a solid, well-made camera and generally very reliable. An R3 MOT will cost about 40 per cent more than a basic R3. However, if you do feel that a winder is important you should be able to find a good R4s (very reliable economy version of the R4 with manual and aperture-priority modes only) at around this price level, and that camera would be my recommendation. This model will take most current accessories, including the 2FPS winder or 4FPS motor and the interchangeable focussing screens. Flash is dedicated but not TTL.

Points to watch for in the R3 and R4 models are that the metering system is working correctly in each of the modes, and that the winder mechanism operates smoothly. Again, check the shutter

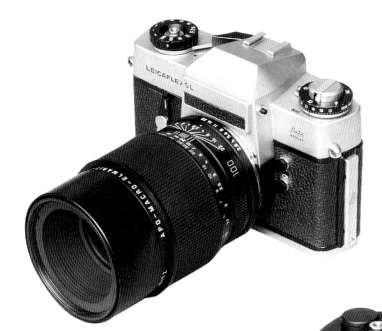

LEICAFLEX SL
The Leicaflex SL was
very well made and is a
good secondhand buy.
Most current lenses,
including the 100/2.8
Apo shown here, will
fit (see text and table
on p147)

LEICA R3
The R3 was the first
Leica with the option
of automatic exposure.
It is well made and
available secondhand
at reasonable prices

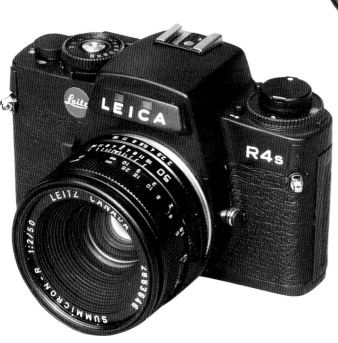

LEICA R4s
The Leica R4s,
although lacking the
shutter-priority and
programme modes of
the R4, is a good
secondhand buy. It
takes all current lenses
and accessories. The
later Mod 2 (or P in
USA) is worth looking
out for

accuracy and evenness of travel at the higher speeds by exposing a short length of film.

LENSES

Naturally over the years there have been changes in the lenses available for the Leica Reflex cameras. Not only optical or mechanical improvements have been made, but also modifications to the linkage between body and lens for exposure control and viewfinder information. Nevertheless there is a surprising degree of compatibility. The table on p144 summarises the position.

My advice is to buy triple-cam lenses if at all possible, as these are usable on any model should you upgrade or add to your outfit. Twin-cam-only lenses are correct for the SL and SL2 and they are available secondhand much cheaper than triple-cam, but this reflects the cost of adding the third cam should you upgrade from the SL to an R3 or later body. Avoid single-cam lenses altogether. They can only be used on the original Leicaflex and conversion costs are very high.

You can generally pick up twin- and triple-cam 35mm, 50mm, 90mm and 135mm lenses fairly easily and at very reasonable prices secondhand. These are all very good optically, but if possible look for later versions with E55 filter mounts and, in the case of the 35mm lenses, look for the later optical design above serial number 2517850 (35/2.8) and serial number 2791416 (35/2). More specialist lenses and focal lengths may be a little more difficult to find at reasonable cost, but this is because in these cases secondhand prices inevitably have a close relationship to prices for new items.

With any lens, check that there are no obvious signs of damage to the mount or lens elements. See that the lens focusses smoothly throughout the range, that the diaphragm is not sticking (ie it stops down and opens up instantly when the shutter is fired) and that the lens fits smoothly, and locks firmly, onto the body.

CONCLUSION

By buying secondhand and shopping around you can put together a very practical Leica outfit at reasonable cost. For the price of a new R5 with standard lens it would be possible to buy an excellent secondhand R4s with, say, 28/2.8, 50/2 and 135/2.8 lenses in very good condition. This would be a very practical outfit to start with.

If you know a keen Leica user don't hesitate to ask him or her for advice. There is great camaraderie with this marque and an unusual willingness to share experience and know-how, as well as good sources of used equipment.

LEICA REFLEX COLLECTABLES

So far the Reflex cameras have on the whole escaped the attentions of that element of Leica collectors preoccupied with 'investment' rather than having a genuine interest in the equipment and its history. There are, of course, some rare and special items but even these have not yet reached the inflated prices that some rangefinder Leicas command.

Leica itself has produced fewer Reflexes aimed specifically at collectors (eg gold-plated models). My own view is that the interesting cameras or lenses for a collection are not the artificially created ones, but those intended as normal user items which for some reason or other were made in relatively small quantities. Other worthwhile collectables are models representing an important stage in the development of the marque. Cutaways and dummies of most 'R' models have been made for display purposes and these (especially cutaways) are particularly interesting and sought after by collectors.

ORIGINAL LEICAFLEX

The original Leicaflex is now twenty-five years old and mint examples are beginning to excite collectors' interest. A very few of this model were produced in a black paint finish and these command much higher prices.

LEICAFLEX SL

The collectable SL cameras are the MOT version together with the black paint and black chrome versions of the standard SL body. These do not yet command too much of a premium over the silver chrome model and are therefore interesting. In 1972 special models of the SL bearing the Olympic logo were produced to commemorate the Olympic Games held that year in Munich, Germany. These too are beginning to appreciate steadily.

LEICAFLEX SL2

Because relatively few were produced, and because this was the ultimate development of the Leicaflex series with a great reputation as a professional workhorse, the SL2 has never been cheap. Silver chrome models are slightly rarer than black and command a higher price, but the MOT version is the genuinely rare 'work' camera. Specially engraved versions of the standard cameras were produced in 1974 for the fiftieth anniversary of the Leica's introduction to the public, and these too sell at premium prices.

LEICAFLEX 1
The original Leicaflex
is now becoming of
some interest to
collectors

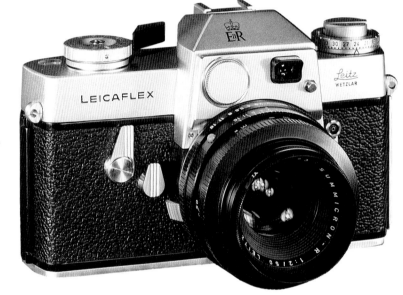

ROYAL LEICAFLEX
A special Leicaflex
supplied to Her
Majesty Queen
Elizabeth II. Note the
monogram

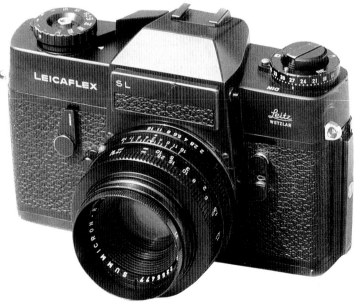

RARE LEICAFLEX SL
The black chrome
Leicaflex SL was made
in comparatively small
numbers

BROCHURE FOR LEICA
'SPECIALS'
Some Leica advertising
literature for 'Specials'

LEICA R3

The R3 and R3 MOT were produced mainly in black chrome, but about 4000 were made in silver chrome finish and they command a modest price premium.

A number of special models of the R3 were produced, viz the Safari model in khaki green finish (5000 made), the gold-plated Barnack centenary model (1000 made) and the LHSA (Leica Historical Society of America) engraved (100 made).

Of the standard production versions the most interesting are the initial production series of 1000 made in Wetzlar. Subsequently all R3s were made in Portugal and the rarity of the German version has pushed up its price, but again not too drastically.

LEICA R4

Special versions of the R4 are a gold-plated edition of 1000 offered in 1984, and a batch of 600 especially engraved 'Jesse Owens' offered as an outfit with a similarly engraved 70–210mm Vario Elmar to commemorate the Golden Jubilee of the great athlete's performances at the 1936 Olympic Games. The latter version was available in North America only, as was an earlier batch of 200 issued to commemorate the scaling of Everest by a Canadian expedition in 1982.

LEICA R5, R6, R-E

At the time of writing no special models or 'rare' cameras have emerged other than the single platinum Leica R6 auctioned in

1989 at Christies, London. The proceeds from the sale of this camera (£25,000) were given by Leica to the Worldwide Fund for Nature.

LENSES

When the Leicaflex was first introduced in 1965 a very few 35/2.8 and 50/2 lenses were produced in silver chrome rather than the usual black anodised finish. Other lenses with special finish were 28/2.8, 50/2, 50/1.4 and 180/4 produced in khaki green finish to match the Safari R3. Fairly rare normal production lenses are the 400/5.6 and 560/5.6 Telyt lenses offered between 1969 and 1971 for use with the Televit rapid focussing mount. Also available briefly around 1972–74 was the 800/8 Minolta Rokkor mirror lens for 'R' cameras.

TABLES

					LEICA REFLEX CAMERAS			
Camera	Year of manufacture	Operating modes	Metering system	Shutter speeds	Comments	Winder or motor as accessory	Inter-changeable focussing screens	Lens camming requirements
LEICAFLEX I/II	1965–68	Manual	Built-in non-TTL	1–1/2000 + B	Non-TTL, clear screen focussing possible only on centre spot	No	No	Single, twin or triple
LEICAFLEX SL	1968–74	Manual	TTL spot	1–1/2000 + B	⎫ Special motorised ⎬ versions were ⎭ made	No	No	Twin or triple
LEICAFLEX SL2	1974–76	Manual	TTL spot	1–1/2000 + B		No	No	Twin or triple
LEICA R3	1976–80	Manual and aperture-priority auto	TTL spot and averaging	4sec– 1/1000 + B (manual and auto)		No	No	Triple or 'R'
LEICA R3 MOT	1978–80	Manual and aperture-priority auto	TTL spot and averaging	4sec– 1/1000 + B (manual and auto)		Yes (winder)	No	Triple or 'R'
LEICA R4	1980–87	Manual, aperture-priority auto, programme auto, shutter-priority auto	TTL spot and averaging			Yes (both)	Yes	Triple or 'R'
LEICA R4s	1983–86	Manual and aperture-priority auto	TTL spot and averaging	1–1/1000 + B (manual) 8–1/1000 (auto)	Simplified version of R4	Yes (both)	Yes	Triple or 'R'
LEICA R4s Mod 2	1986–88	Manual and aperture-priority auto	TTL spot and averaging	1–1/1000 + B (manual) 8–1/1000 (auto)	R4s with some R5 improvements – better mode lock and easier compensation	Yes (both)	Yes	Triple or 'R'
LEICA R5	1987–	Manual, aperture-priority auto, shutter-priority auto, variable pro-gramme auto	TTL spot and averaging plus TTL flash	1/2– 1/2000 + B (manual) 15–1/2000 (auto)	Much improved R4, TTL flash, variable programme, adjustable finder correction, better mode lock, easier compensation	Yes (both)	Yes	Triple or 'R'
LEICA R6	1988–	Manual	TTL spot and averaging plus TTL flash	1–1/1000 + B (manual)	Manual version of R5, improved meter sensitivity, mirror lock and viewfinder illumination	Yes (both)	Yes	Triple or 'R'
LEICA R-E	1990–	Manual and aperture-priority auto	TTL spot and averaging plus TTL flash	½–1/2000 + B (manual) 15–1/2000 (auto)	Simplified version of R5	Yes (both)	Yes	Triple or 'R'

LEICA 'R' LENS COMPATIBILITY

LEICA LENS CAMS for exposure control and finder information:

Single cam – for Leicaflex I/II only
Twin cam – for Leicaflex SL and SL2 and Leicaflex I/II
Triple cam – this is twin cam with added 'R' cam – for all Leica SLRs
'R' cam – for R3, R4, R4s, R5, R6 and R-E only – *not* suitable for
 Leicaflex I/II, SL or SL2 cameras

With the exception of the 50/2 Summicron which was also made with 'R' cam only, lenses from 1976 onwards have generally been fitted with all three cams. Since 1988, however, Leica has fitted 'R' cam only to certain popular lenses viz 28/2.8, 35/2.8, 50/1.4, 50/2, 60/2.8, 80/1.4, 90/2.8 and 90/2 lenses, but all except the 80/1.4 can be modified to triple cam by Leica Service Centres.

Single and twin cam lenses earlier than 1976 may have been modified to full triple cam specification. Check by looking at rear of the lens (see illustration below). Note that the 15/3.5, 16/2.8, 24/2.8, 35/1.4 and 80–200/4.5 zoom will not fit Leicaflex I/II or Leicaflex SL.

It should be noted that although they will fit, any long or large diameter lenses will interfere with the metering system of the Leicaflex I/II and their use is not recommended on this camera.

LEICA REFLEX LENS CAMS

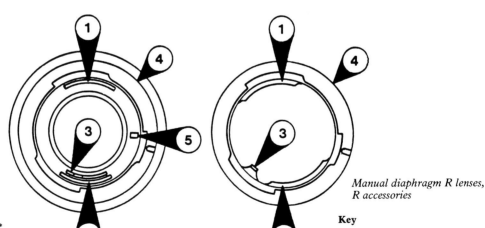

Auto diaphragm R lenses

Key

1 1st Cam for LEICAFLEX*
2 2nd Cam for SL and SL2
3 3rd 'R' Cam for R3, R4, R5, R6, and RE
4 Red Index
5 Auto Diaphragm Coupling

Notes

Exposure measurements are made at full aperture. Cams 'instruct' meter what this is and the compensation required to suit the use of smaller apertures.
 Single and Twin Cam lenses discontinued.
*Also for operating viewfinder display of aperture on SL2.

*Manual diaphragm R lenses,
R accessories*

Key

1 Static Cam 1 for LEICAFLEX
2 Static Cam 2 for SL and SL2
3 Static Cam 3 for R3, R4, R5, R6, and RE
4 Red Index

Notes

Static Cams zero the meter to allow accurate stop-down metering. With 'FLEX, Static Cam 1 brings meter to the f/11 equivalent.
 Static Cams 1 and 2 may appear to be a continuous surface on some items.
 Items with Static Cam(s) 1 or 2 or 1 and 2 discontinued.

	Discontinued	New design	Cosmetic change	Note
LEICA REFLEX LENSES				
DISCONTINUED AND DESIGN CHANGES (DATE OR SERIAL NUMBER)				
19/2.8		1990		
21/3.4	1968			
35/2		2791417		
35/2.8		2517851	2928901	Built-in hood
50/1.4			2806501	Built-in hood E55 filter
50/2		2777651		
60/2.8			3013651	E55 filter
90/2.8		3260100		
135/2.8		1968	2772619	E55 filter
180/2.8		2939701		
180/3.4			2947024	E60 filter
250/4		3050601		
400/5.6	1971			
560/5.6	1971			
800/8	1978			Minolta mirror lens
35–70/3.5			3393301	E67 filter Non-rotating mount
80–200/4.5	1978			
45–90/4.5	1982			Angenieux lens
75–200/4.5	1984			

'M' VISOFLEX (V) LENSES ON THE LEICA REFLEX CAMERA		
	Basic adapter	Other adapters needed
65/3.5 Elmar*	14167	16464
125/2.5 Hektor	14167	16466
135/2.8 Elmarit (lens head)	14167	16462
135/4 Tele Elmar* (lens head)	14167	16464
200/4 Telyt	14167	16466
280/4.8 Telyt	14167	16466
from No 2340953	14167	–
400/5.6 Telyt	14167	–
400/6.8 Telyt	14167	–
560/5.6 Telyt	14167	–
560/6.8 Telyt	14167	–
800/6.3 Telyt S	14167	–
* Can be used on bellows 'R' via adapter		

ACCESSORIES FOR OLDER LENSES								
R-lens	Internal lens thread	Diameter in mm	Lens hood	Lens cap	Rear cover	Filter-size	Adapter for Series filters	ELPRO near focussing attachment
SUPER-ANGULON-R 3.4/21 11803	M 67x0.75	70	4)	14144	4)	Series 8	Lens hood	–
SUMMICRON-R 2/35 11227 up to No. 2791416	M 48x0.75	51	12509 1)	14172	14162	Series 7	Lens hood	–
ELMARIT-R 2.8/35 11101 up to No. 2517850	M 44x0.75	47	4)	–	14162	Series 6	14160	–
up to No. 2928900	M 48x0.75	51	12509	14172	14162	Series 7	Lens hood	–
SUMMILUX-R 1.4/50 11875 up to No. 2806500	M 48x0.75	51	4)	14172	14162	Series 7	Lens hood	–
SUMMICRON-R 2/50 11228 up to No. 2777650	M 44x0.75	47	4)	–	14162	Series 6	14160	16531 16532
MACRO-ELMARIT-R 2.8/60 11203 up to No. 3013650	M 60x0.75	63.7	12514	14290	14162	Series 8	Lens hood	–

ACCESSORIES FOR OLDER LENSES *continued*								
R–lens	Internal lens thread	Diameter in mm	Lens hood	Lens cap	Rear cover	Filter-size	Adapter for Series filters	ELPRO near focussing attachment
SUMMICRON-R 2/90 11219 up to No. 2770950	M 54x0.75	70	built-in	14144	14162	Series 7	14161	16533
up to No. 3381676	M 55x0.75	70	built-in	14289	14162	E 55	14225	16543
ELMARIT-R 2.8/90 11239 up to No. 2809000	M 54x0.75	65	built-in	14089	14162	Series 7	14161	16533
up to No. 3260100	M 55x0.75	65	built-in	14289	14162	Series 7	14225	E55
MACRO-ELMAR 4/100 11230 up to No. 2933350	M 54x0.75	65	built-in	14089	14162	Series 7	14161	–
ELMARIT-R 2.8/135 11211 up to No. 2772618	M 54x0.75	65	built-in	14089	14162	Series 7	14161	16534
ELMARIT-R 2.8/180 11919 up to No. 2939700	M 72x0.75	78	built-in	14152	14162	Series 8	4)	–
APO-TELYT-R 3.4/180 11240 up to No. 2947023	M 59x0.75	65	built-in	14089	14162	Series 7.5	4)	–
TELYT-R 4/250 11920 up to No. 3050600	M 72x0.75	78	built-in	14152	14162	Series 8	4)	–
TELYT-lens unit 5.6/400 (TELEVIT-R)	–	98	built-in	14295	4)	Series 7	Filter-slot	–
TELYT-lens unit 5.6/560 (TELEVIT-R)	–	120	built-in	4)	4)	Series 7	Filter-slot	–
VARIO-ELMAR-R 3.5/35–70 to No. 3393300	M 60x0.75	69	built-in	14290	14162	E 60	14263 for Series 7.5	–
VARIO-ELMAR-R 4.5/80–200 11224	M 55x0.75	72	built-in	14261	14162	E 55	14225 for Series 7	16543 16544
VARIO-ELMAR-R 4.5/75–200 11226	M 55x0.75	70	built-in	14289	14162	E 55	14225 for Series 7	16543 16544

1)=Leather case for same: 14621
4)=Replacement may be obtainable from the Leica Service Centre: please enquire.

ACKNOWLEDGEMENTS

This book would not have been possible without the support of many Leica and other friends who have been a constant source of help and advice, for which I am most grateful. I would particularly like to thank my wife Valerie, who has always been so tolerant and understanding of my enthusiasm for photography and the Leica, and who typed and helped me to edit and proofread the text; Wendy Williams who typed the captions; Dr Verena Frey; Hans Gunter Von Zydowitz; Ulrich Hindtner and Aaron Altman of Leica Camera who have been so helpful and supportive of the project; Piers Spence, Sarah Widdicombe and Brenda Morrison of David & Charles for their considerable professional skills which have been applied in a way thoroughly sympathetic to the realisation of the original concept; Tony Godwin for providing at short notice three of his excellent black-and-white photographs; and Dr Heather Angel FRPS who has given me much valuable advice and encouragement throughout.

The following registered Trade Marks are used with the kind permission of Leica Camera GmbH:

LEICA, LEICAFLEX, SUMMILUX, SUMMICRON, ELMARIT, ELMAR, VARIO-ELMAR, TELYT, APO-TELYT, SUPER ANGULON, PHOTAR, HEKTOR, NOCTILUX.

BIBLIOGRAPHY

LEICA INFORMATION

Leica Camera GmbH. *Handbook of the Leica System* (Leica Camera GmbH)

Frey, Dr Verena. *75 Years of Leica Photography* (Leica Camera GmbH)

Grossmark, Derek. *Leica Price Guide* (Hove Foto Books)

Kisselbach, Theo. *Leica R4 Reflex Manual* (Hove Foto Books)

Lager, James. *Leica Illustrated Guide I/II/III* (Morgan & Morgan)

Laney, Dennis. *Leica Accessory Guide* (Hove Foto Books)

Laney, Dennis. *Leica Lens Practice* (Hove Foto Books)

Laney, Dennis and Tomkins, Brian. *Leica Pocket Book* (Hove Foto Books)

Matheson, Andrew. *Leica R5 to R3* (Hove Foto Books)

LANDSCAPE

Adams, Ansel. *The American Wilderness* (Little, Brown)

Adams, Ansel. *Yosemite and the Range of Light* (Thames & Hudson)

Angel, Heather. *Landscape Photography* (Oxford Illustrated Press)

NATURE AND WILDLIFE

Angel, Heather. *The Book of Nature Photography* (Ebury Press)

Dalton, Stephen. *Borne on the Wind* (Chatto and Windus)

Campbell, Laurie. *The RSPB Guide to Bird and Nature Photography* (David & Charles)

Shaw, John. *The Nature Photographer's Guide to Professional Field Techniques* (Amphoto)

TRAVEL

Lichfield, Patrick. *Travel Photography* (Constable)

PORTRAITURE

Lord Snowdon. *Snowdon, Sittings 1973–1983* (Weidenfeld and Nicholson)

GENERAL

Benser, Walter. *My Life with the Leica* (Hove Foto Books)

Haas, Ernst. *The Creation* (Michael Joseph)

COLOUR ILLUSTRATIONS: *Technical Summary*

Page	Title	Camera	Lens	Special Accessory	Film
2	Red Rock Canyon, Utah	Leica R5	35/2 Summicron	Circular polariser	Kodachrome 25 Pro
4	Superior Quality	Leica R4	100/4 Elmar	Tripod, plain screen	Kodachrome 64
6	Mull, Scotland	Leica R3	28/2.8 Elmarit	–	Kodachrome 25
13	The Old Bridge at Wetzlar	Leica R4	21/4 Super Angulon	–	Kodachrome 25 Pro
	Autumn in Manhattan	Leica R4	21/4 Super Angulon	–	Kodachrome 25 Pro
17	Insects Mating	Leica R6	100/2.8 Apo Macro with Elpro	TTL flash, grid screen	Fuji Velvia
20	The Syd Lawrence Orchestra	Leica R6	90/2 Summicron	–	Kodachrome 200 Pro
25	Wells Cathedral (2 photos)	Leica R4	28/2.8 PC Super Angulon	Grid screen	Kodachrome 25 Pro
27	The Rothaus, Monschau	Leica R4	21/4 Super Angulon	–	Kodachrome 25 Pro
29	Grand Canyon	Leica R4	90/2 Summicron	–	Kodachrome 64 Pro
31	Barge on the Mosel 1	Leica R5	21/4 Super Angulon	–	Kodachrome 64 Pro
	Barge on the Mosel 2	Leica R5	90/2 Summicron	–	Kodachrome 64 Pro
33	Boeing 747 Take off	Leica R4	280/2.8 Apo Telyt	Motor drive, grid screen	Kodachrome 64 Pro
35	The Royal Yacht Brittania at Cowes	Leica R5	70/210 Vario Elmar	Grid screen	Fuji Velvia
	Shag on Nest, Bass Rock	Leica R6	180/3.4 Apo Telyt with 2x Extender	Grid screen	Kodachrome 200 Pro Fuji Velvia
40	Leica 111f Outfit	Leica R4	100/2.8 Apo Macro	Tripod, grid screen	Kodachrome 25 Pro
41	John Morris	Leica R6	90/2 Summicron		Fuji Velvia
42	RAF Tornado	Leica R4	280/2.8 Apo Telyt	Motor Drive, grid screen	Kodachrome 64 Pro
45	American Locomotive, Utah	Leica R4	35/2 Summicron	–	Kodachrome 25 Pro
	Burg Cochem	Leica R5	180/3.4 Apo Telyt	–	Kodachrome 64 Pro
49	BMW	Leica R4	35/2 Summicron	Graduated grey filter	Kodachrome 25 Pro
50	Pulteney Bridge, Bath	Leica R5	35/2 Summicron	Circular polariser	Kodachrome 25 Pro
56	Foundry	Leicaflex SL2	35/2 Summicron	Flash	Kodachrome 200 Pro
59	Trees and Snow	Leica R4	35/2 Summicron	–	Kodachrome 25
60	The Mosel Near Piesport	Leica R5	180/3.4 Apo Telyt	–	Kodachrome 64 Pro
	Tombstone Courthouse, Arizona	Leica R4	21/4 Super Angulon	–	Kodachrome 25
62	Hong Kong Floating Restaurant	Leica R4	50/2 Summicron	Table Tripod	Kodachrome 64
63	Sunset, Stockport	Leicaflex SL	50/2 Summicron	–	Kodachrome 25
65	Water Droplets	Leica R4	100/2.8 Apo Macro Elmarit	Elpro, Grid Screen, Tripod	Kodachrome 25 Pro
	Hibiscus, Crete	Leica R4	90/2 Summicron	Elpro 3	Kodachrome 25
67	Poppy Bud	Leica R6	100/2.8 Apo Macro Elmarit	Tripod Grid Screen	Fuji Velvia
	Poppy Flower	Leica R6	100/2.8 Apo Macro Elmarit	Tripod Grid Screen	Fuji Velvia
68	Dragonfly	Leica R4	70/210 Vario Elmar	–	Kodachrome 64
70	Marsh Orchid	Leica R4	65/3.5 Elmar	Bellows 'R', Tripod	Kodachrome 25
	Using Bellows	Leicaflex SL2	50/2 Summicron	–	Kodachrome 64
71	Speedwell	Leica R4	65/3.5 Elmar	Bellows 'R', Table Tripod	Kodachrome 25
73	Garden Spider	Leica R4	100/4 Macro Elmar	Bellows 'R', Table Tripod	Kodachrome 64
	Hoverfly	Leica R5	100/2.8 Apo Macro Elmarit	TTL Flash	Kodachrome 25 Pro
78	Peter	Leicaflex SL	135/2.8 Elmarit	–	Kodachrome 25
79	Thai Dancer	Leica R4	90/2 Summicron	–	Kodachrome 25
80	Umbrella Painter	Leica R3	50/2 Summicron	Flash	Kodachrome 25
81	Striding Edge, Helvellyn	Leica R4	35/2 Summicron	–	Kodachrome 25
	Hill Tribe Children	Leica R4	28/2.8 Elmarit	–	Kodachrome 25
82	Bubble Girl	Leica R3	90/2 Summicron	–	Kodachrome 64
83	Thomas	Leica R5	90/2 Summicron	–	Kodachrome 25 Pro
85	Zambesi Sunset	Leica R4	35/2 Summicron	–	Kodachrome 25 Pro
86/87	Tree, Ullswater	Leica R4	35/2 Summicron	–	Kodachrome 25
88	Narrowboat 1	Leica R5	35/2 Summicron	–	Kodachrome 25 Pro
	Narrowboat 2	Leica R5	35/2 Summicron	–	Kodachrome 25 Pro
89	Grand Canyon in Winter	Leica R4	35/2 Summicron	–	Kodachrome 64 Pro
90/91	Grand Canyon in Winter	Leica R4	35/2 Summicron	–	Kodachrome 64 Pro
92	Rainbow, Dollar, Scotland	Leica R4	21/4 Super Angulon	–	Kodachrome 64 Pro
	The Head of Ullswater	Leica R4	35/2 Summicron	–	Kodachrome 25 Pro
94	Sunrise, Monument Valley	Leica R5	100/2.8 Apo Macro Elmarit	–	Kodachrome 64 Pro
95	Sharrow Bay	Leica R4	16/2.8 Fisheye Elmarit	–	Kodachrome 25 Pro
97	Venice	Leica R3	21/4 Super Angulon	–	Kodachrome 25

COLOUR ILLUSTRATIONS: *Technical Summary*

Page	Title	Camera	Lens	Special Accessory	Film
97	Maps and Guides	Leica R4	60/2.8 Macro Elmarit	Tripod	Kodachrome 25 Pro
99	Bryce Canyon 1	Leica R4	35/2 Summicron	–	Kodachrome 25 Pro
	Bryce Canyon 2	Leica R5	90/2 Summicron	–	Kodachrome 64 Pro
100/101	Manhattan	Leica R5	21/4 Super Angulon	–	Kodachrome 64 Pro
102	Buddhist Monk	Leica R4	28/2.8 Elmarit	–	Kodachrome 64
103	Sailing Junk, Hong Kong	Leica R4	180/2.8 Elmarit	–	Kodachrome 64
	Royal Palace, Bangkok	Leica R4	90/2 Summicron	–	Kodachrome 25
104/105	Take off from JFK	Leica R5	35/2 Summicron	–	Kodachrome 64 Pro
106	Fire Engine, Cape May	Leica R4	21/4 Super Angulon	–	Kodachrome 25 Pro
107	Kenworth Truck, Arizona	Leica R4	21/4 Super Angulon	–	Kodachrome 25 Pro
108	Mammoth Hot Springs	Leica R5	35/2 Summicron	–	Kodachrome 25 Pro
109	Rock Rose	Leica R6	100/2.8 Apo Macro Elmarit	Tripod, Grid Screen	Fuji Velvia
110	Cactus, Death Valley	Leica R4	35/2 Summicron	–	Kodachrome 25 Pro
112	Chaffinch	Leica R4	400/6.8 Telyt	Bean Bag, Grid Streen, Winder	Kodachrome 200 Pro
	Sleeping Owl	Leicaflex SL	135/2.8 Elmarit	–	Kodachrome 64
113	Gannets, Bass Rock	Leica R4	280/2.8 Apo Telyt	Motor Drive, Grid Screen	Kodachrome 64 Pro
114	Orange Tip Butterfly	Leica R4	60/2.8 Macro Elmarit	–	Kodachrome 64 Pro
115	American Ground Squirrel	Leica R5	90/2 Summicron	–	Kodachrome 64 Pro
116	Rhino, Zambia	Leica R4	180/2.8 Elmarit	–	Kodachrome 64 Pro
	Elephant, Zambia	Leica R4	180/2.8 Elmarit with 2x Extender	–	Ektachrome 400
118/119	Universal Studios, LA	Leica R4	28/2.8 Elmarit	–	Kodachrome 25
120	Hot Air Balloon, Bath	Leicaflex SL2	180/3.4 Apo Telyt	–	Ektachrome 100
121	Wind Surfer	Leica R5	280/2.8 Apo Telyt with 2x Extender	Motor Drive	Kodachrome 200 Pro
122	Eartha Kitt on Stage	Leica R6	90/2 Summicron	–	Kodachrome 200 Pro
123	Little Moreton Hall	Leica R6	21/4 Super Angulon	–	Fuji Velvia
124	Test Section	Leicaflex SL2	21/4 Super Angulon	Tripod	Fuji Reala
126/127	House, Carefree, Arizona	Leica R4	35/2 Summicron	–	Kodachrome 25

All the above colour illustrations © Brian Bower
Black and white illustrations on pages 51, 84 and 125 © Tony Godwin
Other black and white illustrations by the author or reproduced by kind permission of Leica Camera GmbH
Leica Camera GmbH have also given permission for the use of various line diagrams and certain of the tables

INDEX

Accessories, 48ff
Animals, 115, 116
Apo Extender 1.4x, 32
 Macro Elmarit 100/2.8, 21, 30, 66
 Telyt 180/3.4, 21, 30
 Telyt 280/2.8, 21, 32
 Telyt 400/2.8, 32
Average reflectance, 57, 58

Beanbag, 43, 44
Bellows unit, 68, 69, 76, 77
Benbo tripod, 53, 71
Berek, Max, 21
Billingham bag, 56
Birds, 111
Black and white films, 125
Bounce flash, 130, 131
Bracketing exposure, 60
B&W filters, 50

Cable release, 71
Camera shake, 42, 43, 71
Canon (AE1), 10
Chrome lenses, 142
Close-up, depth of field, 77; methods, 64ff
Collecting, 135, 139ff
Colour, negative films, 124; transparency films, 117
Computer flash, 129
Converging verticals, 24, 25, 26
Coupling ring, 56

Delayed action, 71
Depth of field, 29, 39, 40, 77
Developers, 128
Discontinued lenses, 145

Effects filters, 50
Electronic flash, 129ff
Elmar 100/4, 30, 66
 65/3.5, 69
Elmarit, 19/2.8, 26
 24/2.8, 26
 28/2.8, 24
 35/2.8, 24
 90/2.8, 30

135/2.8, 30
180/2.8, 30
Elpro lenses, 64, 74
Exposure, 57ff; compensation, 60, 61, 62
Extenders, 34
Eyepiece correction, 14, 15, 39

Family pictures, 82
Fill-in flash, 54, 83, 132
Film, 46, 102, 115, 117ff; speed, 117
Filters, 49; for black and white film, 49
Fisheye Elmarit 16/2.8, 26, 94
Flash, dedication, 54, 129, 130; viewfinder display, 133
Flashguns, 54, 129
Flowers, 110
Focussing, 39, 40; bellows, 68, 76, 77; screens, 39, 47, 48

Gold R3, R4, 141
Graduated filter, 50, 94

Insects, 114

Kine Exakta, 8

Landscapes, 85ff
Leica R-E, 15, 20, 141
 R3, 10, 11, 136, 137, 141
 R4, 12, 136, 141
 R4s, 11, 12, 136, 137
 R4s Mod 2, 12, 136, 137
 R4s Mod P, 12, 136, 137
 R5, 14, 15
 R6, 14, 15, 141
Leicaflex 1, 89, 139, 140
 SL, 89, 135, 137, 139, 140
 SL2, 9, 10, 139, 140
Lens compatibility, 138; coupling cams, 12, 138, 144; design changes, 148; hoods, 21; sections, 24–6; table, 23
Lenses for landscape photography, 94

M flash socket, 129
Macro Adaptor, 64, 68, 75
 Elmarit 60mm, 22, 66
 Flash Unit, 72, 114
 Lenses, 66
Meter sensitivity, 57
Minolta, 10
Mirror lenses, 32; lock-up, 19, 46
Monet, Claude, 85
Monopod, 44
Motor drive, 51, 71, 111, 115; winder, 51, 71, 115

Nature, 109ff
Night photography, 62
Nikon (F), 8

Olympus (OM1), 10
 SL, 139
Outfit cases, 56, 98, 115

PC Curtagon on 35/4, 24
 Super Angulon 28/2.8, 24
Pentax (ES), 10
Perspective, 30, 31; control (PC) lenses, 24, 25
Photar lenses, 24, 77, 69
Planning, 93, 96
Plants, 110
Platinum R6, 141
Ploot reflex housing, 8
Polarising filter, 49, 94
Portraits, 78, 80, 82, 83, 84
Preview lever, 110
Professional films, 128

R Cam, 12, 138, 144
Reflex 500/8, 32
Remote release, 51, 71, 111
Ring combination, 68, 75
Royal Leicaflex, 140

SCA flash system 16, 129
Safari Leica R3, 141; lenses, 142
Secondhand equipment, 135ff
Single cam, 12, 138, 144
Skylight filter, 49

Sports photography, 40
Spot metering, 10, 12, 18, 57
Standard lenses, 22
Summicron 35/2, 24,
 50/2, 22, 143
 90/2, 28, 143
Summilux 35/1.4, 24
 50/1.4, 22
 80/1.4, 28
Super Angulon 21/4, 28
 Elmar 15/3.5, 26

TTL flash metering, 14, 15, 71, 114, 132
Table Tripod, 43, 44, 53
Telephoto lenses, 28, 29, 30, 32
Telyt, 250/4, 32
 350/4.8, 32
 400/6.8, 32, 111
 560/6.8, 32, 111
Travel, 96ff
Triple cam, 12, 138, 144
Tripod, 44, 53, 71
Twin cam, 12, 138, 144

Ultra wide angle, 26
Used equipment, 125ff
UVA filter, 49

Variable programme mode, 17
Vario Elmar 28-70, 33
 Elmar 35-70, 34
 Elmar 70-210, 34, 35, 66
Viewfinder correction, 14, 39; flash indication, 133; magnification, 14
Vignetting, 61
Visoflex lenses and adaptors, 21, 149

Warming filter 81b, 49, 94
Weather, 89
Wildlife, 109ff

X-ray machines, 102

Zeiss, 8, 26
Zoom lenses, 33, 34